Raphael's World

Michael Collins

Published by Messenger Publications, 2020

ISBN 978 1 78812 123 1

Designed by Messenger Publications Design Department
Typeset in adobe Filosofia OT and Book Antiqua
Printed by Hussar Books

Messenger Publications,
37 Leeson Place, Dublin D02 E5V0
www.messenger.ie

RAPHAEL'S
MICHAEL COLLINS
WORLD

To my brother David (1955–2013)
who decorated the world with the colours of the rainbow.

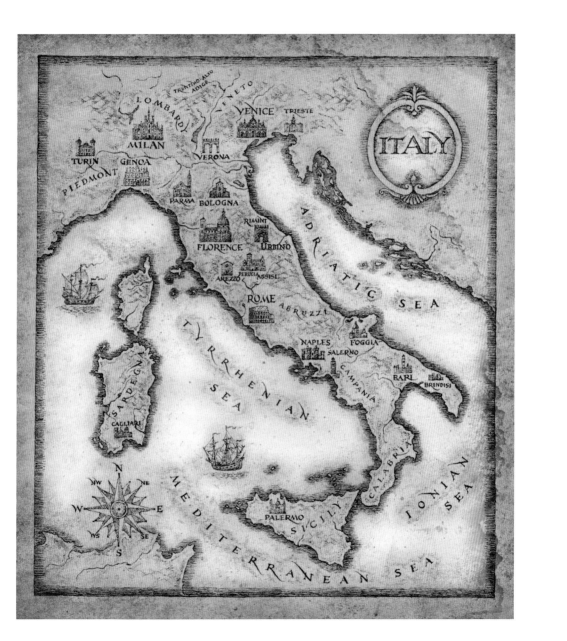

Contents

Contents

Preface

alf a millennium after his death in 1520, the works of the High Renaissance artist, Raphael, still make us pause to contemplate his genius.

In his day, popes, prelates and princes vied with one another for Raphael to paint their portraits or decorate their residences. A large number of wealthy patrons requested his services in order to have their portraits painted for posterity. Several of his works were commissioned as gifts for royal courts.

Raphael was born thirty years after the Fall of Constantinople and the invention of the first moveable type printing press in Germany. When Raphael was eleven, Christopher Columbus crossed the Atlantic from Europe in search of a western route to China and India. Three years before Raphael's death in 1520, Martin Luther called for reform in the Catholic Church, a move which led to decades of violent political and social unrest across Europe. These events were to indirectly affect Raphael and shape his world.

The young Raphael was tutored by his father, a noted artist, who fostered his son's precocious talent. Raphael was fortunate to be born in Italy where artists produced evermore beautiful works and found ready patronage in the Church and the developing merchant classes.

From the sophisticated court of Urbino to the papal court in Rome, Raphael collected admirers and generous patrons. Working at the very summit of the High Renaissance in Italy, he adapted rapidly to new techniques and had an ability to absorb styles and techniques from other artists and combine them into novel forms. While his early training was in tempera, he successfully mastered fresco and oils, and later adapted some of his designs to woven fabrics and new techniques of engraving. From his preparatory drawings and designs, we can see that Raphael worked with extraordinary concentration and discipline. These qualities, combined with his innate talent, explain his enviable success.

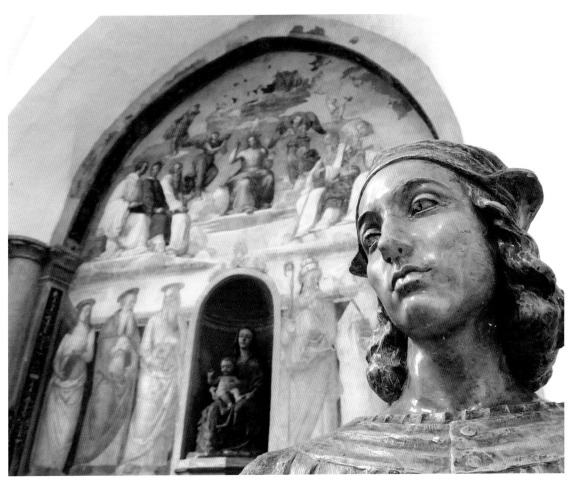

Bust of Raffaello Sanzio, known as Raphael. In the background is a fresco painted by the artist. Chapel of San Severo, Perugia, Italy. Photograph: Eavide Zanin / Shutterstock

Contemporaries attest to Raphael's charm and grace. Physically handsome, he impressed those whom he met by his courtesy and confidence. Raphael's works show a versatility and spontaneity which delighted his patrons. He moved with ease from depicting the Madonna and Christ Child to a semi-naked portrait of a presumed lover

There is so much we do not know about Raphael. Barely a handful of documents survive in his own hand and even these furnish us with little personal information. To understand Raphael, we must look to his surviving works and hundreds of preparatory drawings. These show the development of his thought and interests and open a window on to the world in which he lived.

While Raphael undoubtedly learned the rudiments of art in his father's *bottega*, or studio, scholars are divided over his first formal master. Many believe that he studied at the *bottega* of the Umbrian artist, Pietro Vannucci, known as il Perugino, yet there is no documentation to support the claim. It is possible that he simply remained in his father's *bottega*, after the latter's death in 1494.

Artists in Raphael's day did not paint purely for pleasure. They worked to a commission. Pigments were expensive and no artist could afford to produce a panel or canvas in the hopes of finding a buyer. Raphael was fortunate in his patrons, who recognised his genius and had the means to commission significant works.

Undoubtedly, Raphael's meeting with Pope Julius II (1503–13) assured his success at the papal court. The pontiff was determined to restore Rome after centuries of neglect and make it a worthy seat of the papacy. In gratitude for Raphael's art, the pope conferred on him the Knighthood of the Golden Spur.

Pope Leo X (1513–21) was an even greater admirer of Raphael. A member of the Florentine banking family, the de' Medici, Leo was highly cultured

and proved to be Raphael's most generous and influential patron. Raphael worked at the Apostolic Palace from Leo's accession to the papal throne until his death.

As he became increasingly successful, Raphael employed up to fifty apprentices and artists. In addition, he oversaw a vast team of builders who were steadily replacing the old St Peter's with a new and glorious basilica.

To the joy of his admirers and the envy of his competitors, Raphael's star seemed ever in the ascendant. Courted by wealthy patrons and admired by the humanist circles of Renaissance Italy, Raphael took his place with the greatest artists of his day. He clearly had a competitive streak and was ambitious. There was a rumour that Leo X intended to create him a cardinal.

Raphael's death on 6 April 1520, at the relatively young age of thirty-seven, stunned his contemporaries. Writing from Rome to Isabella d'Este on 7 April, Pandolfo Pico spoke of unusual portents. The roof of the pontiff's rooms had collapsed shortly before, causing Leo to flee for safety and Michelangelo was reported as unwell. While he mistakenly claimed that Raphael was thirty-three at the time of his death, Pico wrote:

> Here nobody speaks of anything else but the death of this fine man, who has finished his first life. But his second life, that of Fame which cannot be touched by Time and Death, shall be everlasting.

Five hundred years later, Raphael's legacy endures.

Michael Collins

Michael Collins
Author

Chapter 1

Historical Background: Alliances and Conflicts

Following the collapse of the western portion of the Roman Empire at the end of the fifth century, the Italian peninsula was attacked by waves of invaders. To preserve their independence, regions established themselves as duchies, republics, principalities and kingdoms.

In the late eighth century, the papacy forged alliances with Frankish kings to defend territories that they claimed from the time of the emperor Constantine three centuries earlier. On Christmas Day in the year 800, Pope Leo III crowned Charlemagne emperor of the Romans in St Peter's Square. The coronation marked the beginning of an era lasting several centuries when the popes and Holy Roman Emperors entered into alliances or abandoned each other according to the politics of the day.

Conflict arose over the selection of bishops and land. Bishops were not simply spiritual governors of dioceses; some were also wealthy landowners, receiving a tithe on the produce of those who worked on their lands. They may not have owned the properties themselves, but as long as they held office they enjoyed the abundant benefices. Properties were held for the good of the diocese but numerous bishops used their position to aggrandise their families and lived more like secular princes. From the end of the eleventh century, many families allied themselves to the emperor or the local bishop.

Life in the Middle Ages was feudal, based on a system where each person knew their rank in the social order. The average life expectancy was about forty years, and infant mortality was high. The aristocracy owed their hereditary titles to the

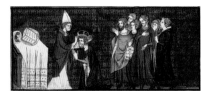

Pope Leo III crowning Charlemagne as emperor on Christmas Day 800; from Chroniques de France ou de St Denis, *fourteenth century*

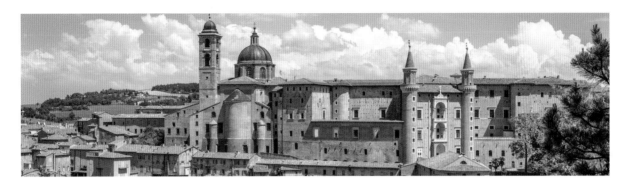

The city of Urbino today

emperor. Vassals, or citizens, received land from the lord in exchange for work and taxes. In times of war, the lord or king raised armies from the young men within his territories.

In the latter half of the eleventh century, a dispute broke out between pope and emperor. The latter sought control over ecclesiastical properties in his territories, particularly the high offices that he wanted to grant to his political support-ers. The popes saw this as an unwarranted abrogation of their spiritual authority.

In Italy those belonging to the faction loyal to the papacy were called Guelphs, an Italianisation of the German Welfs, dukes of Bavaria. Those who owed loyalty only to the emperor were known as Ghibillines, a corruption of Waiblingen, the German town where the faction originated. Various cities and duchies espoused one or other faction, regularly employing mercenary soldiers to augment their urban armies and go to war. The rivalry lasted into the middle of the sixteenth century when new invaders united them against a common enemy.

The city of Urbino had long owed allegiance to the imperial faction. The ruling da Montefeltro family, which dated from the

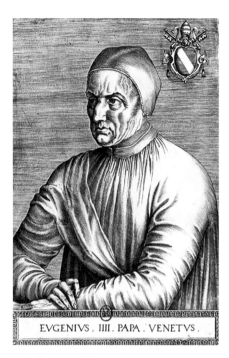

Pope Eugenius IV

twelfth century, had regularly shifted support from the papacy to the emperor according to political necessity.

In 1403, Guidoantonio da Montefeltro inherited extensive lands from his father and further expanded his family holdings. The young Guidoantonio, a *condottiere* (mercenary soldier), wove his way between the papal and imperial factions, siding with one and then unexpectedly switching allegiance for the benefit of his family.

When he died on 21 February 1443, Guidoantonio was succeeded by his son, Oddantonio. The sixteen-year-old had little interest in politics and lacked experience in the cut-throat business of ruling. In April of that year, Pope Eugenius IV made him the first Duke of Urbino as a token of his gratitude for the family's help in fighting the Sforza dynasty of Milan.

Oddantonio's lack of application to the affairs of state gained him a gallery of enemies. During the night of 21 July 1444 conspirators gained access to the private chambers of the new duke, who had retired after a lengthy feast. Along with some loyal bodyguards, Oddantonio was stabbed to death. His corpse was thrown on the floor and the unidentified assassins slipped away.

Contemporaries speculated that Federico, Oddantonio's half-brother, may have been implicated in the murder. Born out of wedlock in 1422, Federico was the son of Guidoantonio and Elisabetta degli Accomandugi. The young Federico was legitimised when his father convinced his wife, Caterina Colonna, a niece of Pope Martin V, to persuade the pope to acknowledge the boy as Guidoantonio's heir. The pope agreed, and in a letter dated 20 December 1424, Martin decreed that the

two-year-old Federico would become Guidoantonio's heir, on the condition that if a legitimate son were to be born, Federico would forfeit his right of inheritance.

On 25 July 1425, a son, Raffaello, was born to the couple, but the infant died within a few hours. Two years later, on 18 January 1427, Caterina Colonna gave birth to another son, who was baptised Oddantonio. Three daughters were born subsequently, but Guidoantonio was satisfied that in Oddantonio, he now had an heir to carry on the family line. He kept Federico away from the court so as not to provoke an eventual challenge to the succession.

At the age of sixteen, Federico became a *condottiere* and was apprenticed to Niccolo Piccinino, one of the most brutal and successful mercenary commanders in northern Italy. Already a gifted horseman and strategist, Federico honed his skill with the sword and bow, taking part in several successful sieges and skirmishes in the region. Federico gained an introduction to Francesco I Sforza of Milan, to whom he successfully offered his services.

The accession of Federico to the lordship of Urbino in 1444 secured the town's fortunes over the next two decades. Federico's military skills brought him lucrative contracts and he quickly amassed a considerable fortune. He skilfully forged alliances with the neighbouring families, to whom he offered his services and protection. His prudent and successful administration of Urbino attracted the attention of neighbours who wanted his lands.

Of all Federico da Montefeltro's foes, none was more constant than Sigismondo Malatesta, lord of Rimini, which

The city of Urbino today

lay to the north of Urbino. The two men, although rivals, were alike in their military prowess and devotion to the arts. Both were unscrupulous in selling their military services to whoever would pay the highest fee. As each campaign was successfully waged and won, the families expanded their holdings.

In 1450, Federico welcomed his father-in-law, Francesco Sforza, who had just become Duke of Milan. During a joust, Federico was hit by a lance which tipped open his visor. As a result of the accident, Federico lost the sight in his right eye and suffered severe damage to the bridge of his nose. He henceforth insisted that artists portray only his left profile, to hide the unsightly scars.

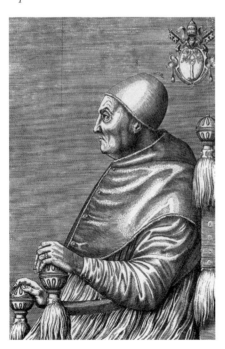

Pope Sixtus IV

In 1462, Federico was appointed to the titular and ceremonial role of *gonfaloniere*, or flagbearer, of the Holy Roman Church by Pope Callistus III, the first Borgia pope. The honorific title was reconfirmed by the humanist Pope Pius II and again by his successor, the della Rovere Pope Sixtus IV, who allied the da Montefeltro family to his own.

In the spring of 1474, three years after his election as pope, Sixtus IV granted Federico da Montefeltro the title Duke of Urbino. The *gonfaloniere* had fought against the Umbrian towns of Todi and Spoleto with troops led by Giuliano della Rovere, the pope's nephew. In a shrewd political move, Federico offered his daughter's hand in marriage to Giuliano's brother, Giovanni, who was named lord of Senigallia and Mondovì. The della Rovere and da Montefeltro families were now entwined in a dynasty to the mutual benefit of both. In an era of shifting alliances, the papacy came to rely on military force to defend its territories, which lay in a swathe across the

Italian peninsula, from encroachments by local landowners who unscrupulously invaded any neighbouring territories whenever the opportunity arose.

Avignon: The 'Babylonian Captivity'

From 1309 to 1376 seven popes had chosen to live in the French town of Avignon. Following the death of Pope Benedict XI in July 1304, fifteen cardinals gathered in Perugia to elect his successor. After eleven months of inconclusive balloting, during which rations were gradually reduced to bread and water, ten of the cardinals succeeded in breaking a pro-French/anti-French deadlock and elected Raymond Bertrant de Got, the archbishop of Bordeaux.

De Got was not a cardinal and was not present at the conclave, so a delegation was dispatched to France to request that he accept the papal nomination. De Got agreed, taking the name Clement V. He refused to travel to Rome, fearing the quarrelling noble families, and chose to be crowned in Lyons. On the advice of the French king, Philip the Fair, Clement took up residence in Avignon, on the left bank of the Rhône river, and the next six popes, all French, opted to remain in the comparative seclusion and safety of the small French town.

When Gregory XI visited Rome in 1377, his intention was to re-establish the papal court in the Eternal City. But his sudden death a year later led to a schism that lasted until Cardinal Oddone Colonna was elected Martin V by the Council of Constance in 1417.

The Duke of Urbino, Federico da Montefeltro and son

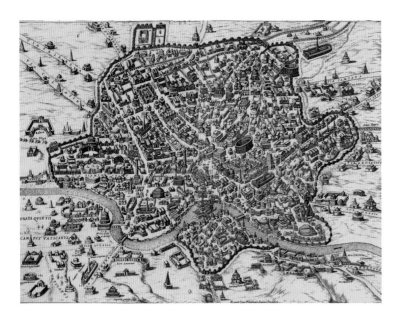

A map of Rome engraved by Giacomo Lauro (1550–1605) in the sixteenth century

The Papacy Returns to Rome

When Martin entered the city in 1420, he found it in a sorry state. The Cathedral of St John had been burned to the ground some thirty years earlier and the roof of the adjacent Lateran palace on the Caelian hill had fallen in. As the papal cavalcade wound its way through the narrow, dank streets, the people turned out to give a jubilant welcome to the new pope who had been born in Genazzano, some forty miles east of Rome. Few understood the complex reasoning behind the election of a member of the aristocratic Colonna family, and most simply wished for the papacy to settle once more in the Eternal City. The century-long absence of the papacy from Rome had diminished Rome economically and the inhabitants knew that the pope held the key to renewed prosperity.

Martin initially settled the papal court at the Basilica of the Holy Apostles beside his family residence close to the ruins of the Roman forum. As he consolidated his position, he moved to the Apostolic Palace at the Vatican and was involved in the restoration of churches and buildings until his death in 1431.

When the scholar Poggio Bracciolini and a companion scrambled up the side of the Capitoline Hill in 1430, a vision of decay awaited them. The forum was little more than a field of felled columns and a farmyard of pigs, cattle and chickens.

Gathering the cardinals around his deathbed in 1455, the humanist pope Nicholas V had explained his reason for attempting to restore the sheen of a glorious past. It was not, he assured the assembled eminences, for mere vainglory, but for the edification of the faithful and the consolidation of the papacy. However, it wasn't until the election of Cardinal Francesco della Rovere in 1471, who took the name Sixtus IV, that the restoration of Rome would continue in earnest.

Chapter 2
The Revival of Rome and the Rise of the de' Medici

Roman Forum as seen from The Capitoline Hill

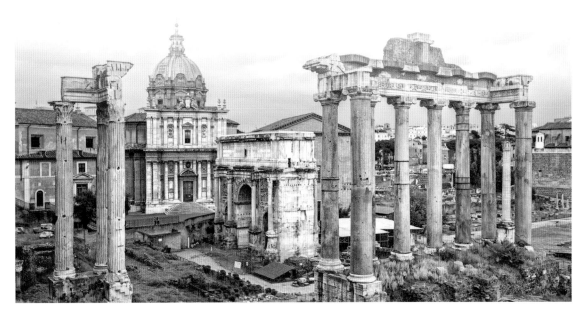

Originally from a fishing family in Liguria, Sixtus had been the minister general of the Franciscan order prior to his surprise elevation as a cardinal by Pope Pius II. Although his first love was theology, he proved to be an energetic city administrator, restoring some thirty churches and erecting seven new buildings in line with the architecture of ancient Rome. He improved sanitation in the city by restoring the *aqua virgine* aqueduct. He ordered the clearance of swathes of slums from the vicinity of the basilicas of St Mary Major and the old St Peters. In a new urban plan for the city he laid out wide streets and erected a marble bridge across the Tiber to join the Vatican fields to the heart of Rome. In order that the citizens understood their debt to his protection, the pope authorised the erection throughout the city of plaques reading: *Sixtus PP IIII Renovator Urbis* (Sixtus the Fourth, Renewer of the City). Most of the works were paid for from the offerings of pilgrims from all over Europe who came to visit the shrines of the apostles, especially during the jubilee years that were held every quarter of a century.

Looking to the Past

In 1480 a young Roman boy was playing in a field opposite the Colosseum. He lost his footing and slipped down a hole where the ground had given way. Briefly dazed, he look around him in the gloom. To his surprise, the area was painted with strange and fantastical figures. When he escaped, word spread of the unusual chamber beneath the field. Curious Romans clambered down into the subterranean chambers, largely filled with mud from centuries of flooding, to explore the hidden chambers

by the light of hemp torches. They looked with amazement on walls painted fourteen centuries earlier. Scholars soon identified the underground structure as the great *Domus Aurea*, the Golden House of the emperor Nero. The rooms, now hidden by centuries of rubble and debris, were once the pride of the Roman emperors.

The discovery sparked a frenzy for ancient Roman artefacts and painting. As statues and columns were dug from the soil by enthusiastic antiquarians, Sixtus established the world's first museum on the Capitoline Hill. Faithful to Nicholas's dream, he rehoused the Apostolic Library in a magnificent hall decorated with scenes inspired by Nero's artists. To commemorate all that he had achieved, Sixtus commissioned Melozzo da Forlì, who had worked at the court of Urbino between 1465 and 1474, to paint a fresco commemorating his appointment of the neo-

Platonist scholar Bartolomeo Sacchi, known as Platina, the first librarian. Melozzo presented the pope, seated in profile to the right, conferring the honour on the kneeling figure of Platina. The full-blown Latin inscription read:

> O Sixtus, you gave your city temples, streets, squares, fortifications, bridges and restored the virgin water aqueduct to the Trevi, you made the harbours safe for sailors and ran defensive walls around the Vatican. Yet the city is further in your debt for the library which once lay in squalor and is now a celebrated place.

Even that roll of honour understates the list of extraordinary achievements. A few years after his election, Sixtus turned his attention to the main chapel of the Apostolic Palace where the pope celebrated liturgies with the papal court. His secretary, Andreas Trapezuntius, noted that the roof was in danger of collapse and that the walls were held up with scaffolding. The pope therefore decided to demolish the chapel entirely and build a new one on its foundations.

Sixtus assigned the project to a Florentine military architect, Baccio Pontelli. The young architect, who was better known for his defensive ramparts, had been recommended to Sixtus, who directed that the new building be modelled on the Temple of Jerusalem, destroyed in AD 70 by Titus, the son of the emperor Vespasian.

Building on the *sacellum maius* began in late 1477; by 1481, the Cosmatic marble floor had been laid and Tuscan artists were already at work on the mural frescos. The new chapel followed the measurements given in the Old Testament. The vast rectangular edifice rose from a broad base and opened

*Facing page: Melozzo da Forlì's fresco
of Pope Sixtus IV with Platina*

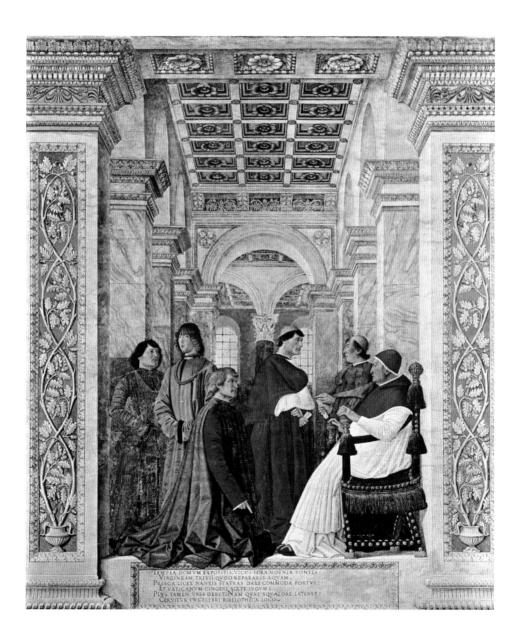

with a series of high clerestory windows, six on each side and two above the high altar. Pontelli installed a barracks on the crenellated flat roof of the chapel, from which vantage point guards could keep watch over the city.

Sixtus had become a cardinal just three years before his election to the papacy at the age of fifty-seven. Distrusting his courtiers, he surrounded himself with members of his family, bestowing enormous power to three nephews and a grand-nephew, two of whom were *condottieri* and two of whom he created cardinals.

Giovanni della Rovere was appointed prefect of Rome and charged with the civil administration of the city. His marriage to Giovanna da Montefeltro, daughter of Duke Federico III da Montefeltro, gave Sixtus considerable influence in the duchy of Urbino. Girolamo Riario, son of Sixtus's sister Bianca, was given the lucrative title captain of the Church immediately upon Sixtus's election. Girolamo's marriage to Caterina Sforza of Milan gained him the cities of Imola and Forlì. Of all the nephews, Girolamo was the pope's favourite. Girolamo's nephew (and Sixtus's grand-nephew), Raffaele Riario, was sixteen when he was created a cardinal in 1477. His mother, Violante, was Girolamo's sister. The last of the close family relations, and the one who was ultimately to be most powerful, was Giuliano della Rovere, created bishop of Ostia and cardinal of the titular church St Peter in Chains near the Colosseum. Sixtus relied heavily on Giuliano's advice and, over two decades later, having served four popes, Giuliano himself ascended the papal throne as Julius II. The favours granted by Sixtus to his nephews almost brought an abrupt end to his pontificate.

The de' Medici: Bankers and Patrons of the Arts

The de' Medici family were originally sheep farmers with lands at Mugello outside Florence. They were moderately successful in the wool trade, but the family fortunes improved principally through the financial acumen of Giovanni di Bicci de' Medici, who established a lending bank in Florence in 1397. Giovanni was a shrewd merchant who challenged the commercial dominance of nearby Siena. As his bank grew, his lending arrangements facilitated merchants travelling from Florence to neighbouring states. In exchange for promissory notes, which meant that merchants no longer had to travel with large quantities of coin, the de' Medici bank charged a small commission. As each city state had its own currency, the bank made further profit from the exchange from one currency to another. Giovanni edged out other banking families, the Alberti, Spini and Ricci, and successfully backed the election of the anti-pope John XXIII in 1410.

Shortly after his election in 1417, Pope Martin V appointed the Spini family bankers to the papal treasury. When the bank collapsed, Martin turned to the de' Medici family for assistance. In 1420, Cosimo, Giovanni's son, went to Rome to train at the de' Medici bank and to further ingratiate his family at the papal court. When he died in 1429, Giovanni was the richest man in

Florence

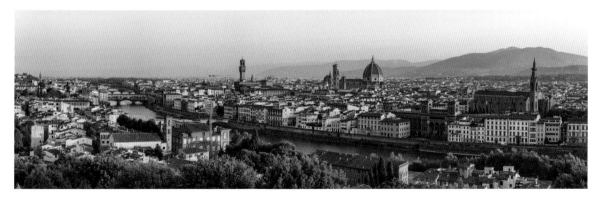

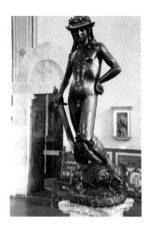

Donatello's bronze statue of David beheading Goliath

Florence. He was succeeded by his sons Cosimo and Lorenzo. When Lorenzo died in 1440, Cosimo took over the sole administration of the bank until his own death in 1464. By that time he had accumulated such wealth as to be among the richest men in Europe. Enea Silvio Piccolomini, later Pope Pius II, astutely observed that 'he is king in all but name'.

While his wealth and social contacts outside Florence stirred up resentment and jealousy among the city's ruling families and politicians, Cosimo was admired as a generous patron of the arts. In 1444, as a newfound understanding and appreciation of ancient Greek and Roman culture was taking hold throughout Europe, Cosimo founded the first public library of Florence. He commissioned the Florentine architect Michelozzo to design the library, which was administered by Dominican friars at the convent of San Marco. At his country villa outside Florence, Cosimo hosted scholars who discussed the ideas that had stimulated the Greek philosophers almost two millennia earlier. During these philosophical dinners, Cosimo listened to great minds discourse upon great Greek and Roman thinkers. In his enthusiasm to collect knowledge from the past, he engaged more than forty copyists, who transcribed ancient papyri and bound them into elegant vellum volumes. Cosimo was generous towards his fellow citizens, and all were welcome to study the newly recovered texts on the wooden benches lining the walls of the library of San Marco. However, as literacy levels were low, few availed of Cosimo's largesse, apart from the Dominican friars.

It was thanks to Cosimo's generosity that several young Florentine artists produced their greatest masterpieces. Donatello's bronze statue of David beheading Goliath was the first 'lost wax' statue produced for a millennium. Daringly, the statue showed the graceful young boy entirely naked in a pose and material none in Florence had seen before. Cosimo also paid for the frescos that Fra Angelico painted in the chapter houses and cells of the friars of San Marco. He reserved one cell for his own private use, and he often retreated there for short periods of prayer and contemplation.

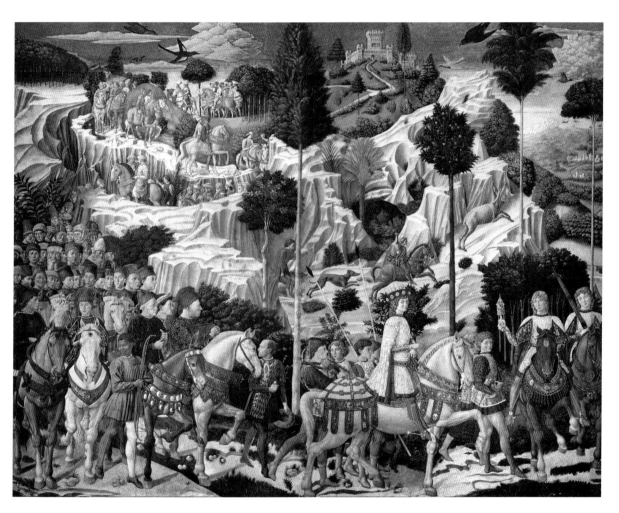

The Procession of the Magi *by Benozzo Gozzoli*

Pope Martin V

The most eloquent expression of Cosimo de' Medici's view of his family and their role within Florentine society is found in a painting by Benozzo Gozzoli in the private chapel in the Palazzo Medici.

In 1442, Pope Martin V gave permission for the de' Medici family to retain a chapel within their new palace, built in Florence between 1445 and 1460. Shortly before the residence was completed, Cosimo instructed Gozzoli to paint a colourful fresco, *The Procession of the Magi*, on three walls of the family chapel. Although it was a private chapel, the space served to impress on visitors the importance of the family by recalling how de' Medici money had facilitated the Council of Florence aimed at reuniting Christendom, twenty years earlier. At Cosimo's direction, Gozzoli depicted several members of the family in the Magi's entourage, as well as members of the imperial court at Constantinople who had attempted an abortive reunification of the Church, which had divided into East and West following the schism of 1054.

When he died in 1464, the city guardians awarded Cosimo the honorific title *Pater Patriae*, father of the fatherland. Cosimo had fastened the grip of his family around the city and little could be done without their consent.

Cosimo was succeeded by his son, 'Piero the Gouty', who called in the debts of several prominent merchants, forcing them into bankrupcy and fuelling anti-de' Medici sentiment. When Piero died in 1469, his son Lorenzo took over the bank. He would be the greatest patron of the arts in late fifteenth-century Florence.

In a lengthy chronicle dedicated to Guidobaldo da Montefeltro, the Duke of Urbino, painter and decorator Giovanni Santi lamented that 'fate has reduced my paternal home to ashes and destroyed all our goods. Much time would be required to relate one after another all the miseries and afflictions of my existence'.

Giovanni Santi composed the poetic chronicle between the years 1484 and 1487 and presented the work to the young duke in 1494 on the death of the duke's father, Federico III. The ostensible purpose of the poem was to commemorate the life and achievements of Federico, but it was also a record of how the fate of his family had long been bound up with that of the da Montefeltro dynasty. It was a courteous way of discharging a debt of gratitude, for Santi owed his family's prosperity to the urbane Duke Federico, whose court was viewed with envy throughout the Italian peninsula and beyond.

The chronicle opens a window not only on to the achievements of Federico 'in peace and war', but also provides a glimpse into Italian life in the fifteenth century, as the Renaissance was beginning to blossom. Giovanni recounted episodes from the lives of countesses, dukes, artists and clerics. To the frustration of the modern reader, he ended his chronicle in the year before the birth of his son, whom he had baptised.

In his dedication to Duke Guidobaldo, Giovanni Santi explained how he had been 'introduced to the admirable art of painting'. It was not without its challenges, as, 'added to domestic cares, it would be a burden even for the shoulders of Atlas'. Yet despite the difficulties he encountered, he proclaimed, 'I am not ashamed to be called a professor of this noble art.'

Chapter 3
Giovanni Santi and his Son Raphael

The Santi family originated in the hilltop village of Colbordola in the duchy of Urbino within the confines of Rimini, which was under the control of the Malatesta family. The founder of the family line, Piero di Sante, was born around 1340. Tax records show that by 1428 the family had reached a comfortable state, owning both land and some farm buildings. Piero had two children, Luca, who died as a youth in 1436, and Peruzzolo, who married Gentilina di Antonio Urbinelli.

Peruzzolo and Gentilina had three children, Sante, Giacoma and Francesca. On the night of 5 August 1446, the family farmhouse was destroyed by mercenaries in the service of Sigismondo Malatesta, lord of Rimini. The wood and brick building was set on fire and the domestic livestock destroyed. The raid by the Malatesta forces, who were looking for food while on campaign, presaged the beginning of more than three decades of conflict between the ruling family of Rimini and the da Montefeltro family of Urbino.

After several futile attempts to rebuild and re-establish himself, Peruzzolo abandoned the family farm. In 1450, he sold his land and, with his wife and two of the children, moved into a small house close to the relative security of the castle of Urbino. The house was rented for thirteen ducats per year from the Confraternity of Santa Maria della Misericordia. Such brotherhoods were popular in the Middle Ages. Members performed charitable acts, such as attending the sick and burying the dead. The black-hooded members were easily recognisable in the street processions that marked the religious feast days throughout the year.

A residence in such close proximity to the castle was a public demonstration of the growing prosperity of the family who now established themselves as grain and provision merchants. Siding with the ruling families required skill, as the wrong choice could mean ruin for generations. As the fortunes of the da Montefeltro family ascended, those of the Santi family rose also.

All three of Peruzzolo's children married. By 1451, Sante had married Elizabetta di Matteo di Lomo and rented a house in the *quadra episcopatus*, the episcopal quarter. The couple had four children, Bartolomeo, Giovanni, Margherita and Santa. The eldest, Bartolomeo, became a priest, Giovanni married Magia di Battista Ciarla and assisted his father in the family business, while both Margherita and Santa married men from Urbino. Santa helped her husband, a tailor, to provide clothing for the citizens of the prosperous town. Magia di Battista brought Giovanni a considerable dowry of 150 ducats, further advancing the family's fortune.

The house where Raphael was born

In addition to providing for the grocery needs of the citizens, Peruzzolo stocked items for the building trade, such as nails, hammers, saws and rope, as well as the pigments used in decoration. He also employed carpenters and carvers to make frames for visiting artists, and gilders to cover the finished frames with gold leaf.

Peruzzolo died in Urbino in March 1457, leaving his house and properties to his family, and a generous bequest of wax candles to be lit during Masses celebrated regularly for his soul in the nearby church of San Francesco. On 28 October of that year, his son Giovanni and a nephew purchased a property from Pierantonio Paltroni, a councillor of the duchy of Urbino. Two years later, on 1 April 1461, Giovanni bought land and, on 16 May 1464, he purchased two houses from the Confraternity of Corpus Domini in the Contrada del Monte district of the town.

While Giovanni managed his father's shop, he became fascinated with painting and gilding. Between 1468 and 1476 he is described in the records of the town hall as a

'master-gilder'. The town was an attraction for some of the emerging artists of the day and, in the mid-1460s, construction had begun on a new palace for the da Montefeltro family.

Da Montefeltro patronage brought artists such as Paolo Uccello, Piero della Francesca, Leon Battista Alberti, Luciano Laurana, Sandro Botticelli and Donato Bramante to Urbino. These masters of colour, shape and form rediscovered the laws of perspective that had been lost for several centuries. In his chronicle, Giovanni enumerated many of the artists he met and whose work his admired. Perhaps with their encouragement, he began to draw and paint. Although Giorgio Vasari, in his *Lives of the Most Illustrious and Excellent Painters, Sculptors and Architects,* dismissed Giovanni Santi as an artist of 'no great merit', it is clear that his patrons found his work satisfactory.

While Piero della Francesca spent some weeks in Urbino painting *The Communion of the Apostles* for the Confraternity of Corpus Domini, he took lodgings in Giovanni's home. The celebrated artist Melozzo da Forlì spent almost a decade between 1465 and 1474 working for the da Montefeltro family and other patrons. It is likely that Giovanni associated with him during these years and informally learned the rudiments of drawing and painting. By the 1470s Giovanni had established himself as a respected artist in his own right.

Life in the Renaissance courts was a bustling combination of feasts, theatrical events, musical entertainments, fireworks and other displays of power and wealth. Tailors and seamstresses were in constant demand to supply ever more sumptuous silk, satin and velvet costumes, while goldsmiths and jewellers produced elaborate rings, necklaces, crowns, brooches and clasps for the increasingly wealthy aristocracy. Giovanni and his small band of assistants were regularly called upon by Federico da Montefeltro to provide staging and decorations for the theatrical entertainments at court.

Raphael's Early Years

According to Vasari, one of his earliest biographers, Raphael was born on Good Friday 1483. As the calendar was later modified by Pope Gregory XIII, the date was either 28 March or 6 April. Another contemporary noted that he was born at about three in the morning, as Holy Saturday was dawning. Following the practice of the time, he was baptised immediately in the parish church.

Raphael's early education was rudimentary. There were no schools and children usually learned from their parents. Giovanni had a passionate interest in writing, which he may have passed on to his son. As the son of a builders' provider, Raphael would have learned the simple rules of mathematics and the art of keeping a ledger.

When Sante di Peruzzolo died in 1484, his son Giovanni inherited the bulk of his estate. In 1489 he obtained a commission to furnish a canvas in oils for the Franciscan church of Santa Maria, the construction of which had begun in 1477. The canvas, *The Visitation of Mary to Elizabeth*, was to stand above the first lateral altar to the left of the portico. Over the next altar, Pietro Vannucci, known as il Perugino, had been commissioned by the friars to paint an annunciation of similar dimensions.

Giovanni Santi and Perugino met either at the moment of commissioning or when they commenced work. The church was nearing completion and the entire choir space behind the high altar was in the process of being decorated with superb wooden *intarsio* panels. The six-year-old Raphael may have accompanied his father. As the elder Santi was busy installing the canvas that he had painted in his studio, the young boy would have wandered through the church. His eye must have been drawn to the wooden panels of the friars' stalls with their ingenious use of light and dark woods to give a sense of depth and perspective. Like any bored child, he may have been given a wooden tablet covered with a prepared surface on which he could draw.

Vasari states that the young boy began his formal training under his father – an assertion later confirmed in a papal brief of 4 October 1511. The term indicates that he was taught the rudiments of art at home. According to Vasari, Raphael was then brought by Giovanni to Perugino's studio in Perugia, where he was enrolled at the age of eight. This, Vasari notes, was accompanied by the tears of his mother, although there is no other contemporary record of Raphael at this young age and it is likely that Vasari was incorrect in his dates. There is no documentation that Raphael ever studied with Perugino.

In early October 1491, Magia Battista di Ciarla died, shortly after having given birth to a daughter. Within a short time Giovanni had married Bernardina di Piero Parte, with whom he had a daughter, Elizabetta.

By now, Giovanni was a successful painter at the court of Urbino, providing theatrical sets and altarpieces for various churches in the Marche region. He was also admired as a portrait painter, a form of art that emerged in the second half of the fifteenth century.

In 1493 Isabella d'Este, wife of Francesco Gonzaga, the marquess of Mantua, summoned Giovanni Santi to paint her portrait as a gift for Isabella del Balzo. In a letter dated 13 January 1494 Isabella describes Giovanni as the 'painter to the Duchess of Urbino' and concludes that people assured her of the likeness. Leonardo da Vinci had also drawn her portrait.

On 20 April, Isabella wrote once more to her namesake, explaining that another portrait, presumed to be by Andrea Mantegna, was not suitable as 'it bears no likeness to us', and that she was waiting for Giovanni Santi to make a suitable portrait. Isabella was a notoriously difficult client, dismissing portraits that failed to exaggerate her best qualities. She indicated that the painter had also been commissioned to paint a portrait of her husband. However, the portraits of Isabella and her husband were never finished. Writing on 25 April, Francesco Gonzaga's brother reported that while in Mantua working on the portraits some months earlier, Giovanni Santi had become ill. Having

spoken with the painter, it was clear that neither portrait was near completion. Giovanni assured the duke and duchess that as soon as he felt better, he would conclude the commission.

Giovanni's health continued to deteriorate and on 26 July 1494 he made a will with the notary Lodovico Baldi, which he revised the following day. He named Raphael and his brother, Don Bartolomeo, his universal heirs. He also made provision for his wife, Bernardina di Piero Parte, and their daughter, Elizabetta. A day later, he summoned the notary to make further changes in a third will. He died on 1 August 1494.

The Discovery of the New World

While Raphael's father worked on his commissions, the age of discovery was in its birth throes. In 1492, a Genoese mariner, Christopher Columbus, set sail from Portugal headed due west. The goal of the expedition was to find a new trade route to the Indies. The presence of Muslim pirate ships in the Mediterranean made it expedient to find a safer passage to the southern hemisphere. By heading west from the Andalusian port of Palos, Columbus and the crew of his three ships hoped to find a new, and possibly shorter route to China, India and the fabled Spice Islands. In an era when the earth was believed to be flat and the sun was thought to revolve around a flat disc, such an endeavour required robust faith and a hearty sense of adventure.

In 1488, Portuguese mariners, led by the explorer Bartolomeu Dias, had succeeded in rounding the Cape of Good Hope on the southernmost extremity of Africa. The appetite for exploration had been whetted and both Spain and Portugal

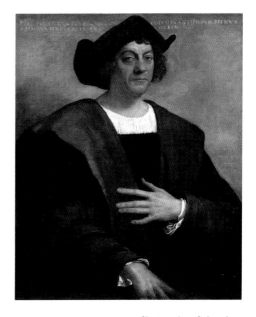

Christopher Columbus

played an increasingly important role in the discovery of new maritime trade routes. In the 1490s the Portuguese mariner, Vasco da Gama, discovered a route that linked the Altantic and Indian oceans. Columbus had approached King John of Portugal in 1484, but had failed to convince the royal advisers of the merits of his plan. In the end, his voyage to find a new trade route was funded by King Ferdinand and Queen Isabella of Castille and Aragon.

On 12 October 1492, thirty-six days after leaving Spain, Columbus's three ships, the *Santa Maria*, the *Pinta* and the *Niña*, arrived in the Bahamas. Although unsure if he had landed in China or Japan, Columbus gathered gold, spices, gems and slaves, which he transported back to Europe, arriving in Portugal on 4 March 1493. He was received in Barcelona by Ferdinand and Isabella. In gratitude for the treasure trove he had brought them, the monarchs awarded Columbus the grandiose title 'admiral of the oceans'.

King John of Portugal was alarmed when he heard of the discovery of the new lands, fearing that Spain might try to appropriate the new territories for itself. He appealed to a bull published by Pope Nicholas V on 8 January 1455 in which the pontiff had urged the Portuguese King Alfonso 'to invade, search out, capture, vanquish and subdue all Saracens and pagans and any other enemies of Christ's wheresoever to be found, and the kingdoms, dukedoms, principalities, dominions, possessions and all moveable and immoveable goods whatsoever held and possessed by them and to reduce their persons to perpetual slavery and to apply and appropriate to himself and his successors the kingdoms, dukedoms, counties, principalities, dominions, possessions and goods, and to covert them to his and their use and profit'.

King John argued that, according to the papal directive, all lands to the west of Portugal ought to become part of his realm. The Spanish monarchs retorted that as they had financed the expedition the territories discoverd by Columbus should belong to the Spanish crown. Unable to settle their grievances, despite several months of diplomatic wrangling, the three monarchs

appealed to Pope Alexander VI, who had been elected just days after Columbus had set sail.

With the bull *Inter Cetera*, dated 4 May 1493, the pope delivered his decision. He drew a line down the map which ran due north to due south about 100 leagues (480 kilometres) west of the Azores and Cape Verde Islands. All territory to the west of the demarcation line would belong to Spain while that to the east was Portugal's.

The judgment clearly favoured Spain and King John protested that as Pope Alexander was Spanish, he was unfairly biased in favour of his native land. Neither side was satisfied with the papal decision. While the pope agreed to alter the line of demarcation in 1494 with the Treaty of Tordesillas, the issue was not finally decided until 1503, shortly before Alexander's death.

In gratitude for the pope's intervention in favour of Spain, Ferdinand and Isabel sent him the first gold from the New World to gild the ceiling of the Basilica of St Mary Major.

The discovery of the Americas had a dramatic impact on Europe. The new lands provided prosperity, with plentiful gold, silver and other precious metals, as well as a vast collection of gems. The initial good will of the early explorers soon gave way to violence as they established their colonies. The exploration of the Americas led to rapacious exploitation of the native population. The Europeans brought disease, the destruction of ethnic groups and what was to be centuries of enslavement. The discovery routes were unknown to the young Raphael but the riches they brought would affect his future career and prosperity.

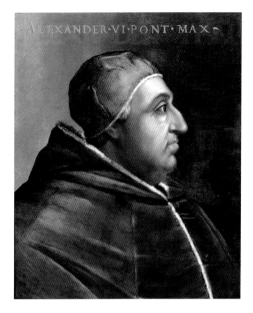

Pope Alexander VI

The Bull / Inter Cetera

Chapter 4
The Artist's Apprenticeship and Early Career (c.1495–1500)

ollowing the death of Giovanni Santi, Raphael's maternal uncle, Don Bartolomeo, became his guardian. In consultation with Simone Ciarla, Don Bartolomeo's brother, it was decided to send the boy to study with Perugino in Perugia. Perhaps Giovanni had already decided that his son should enter the *bottega* when he was twelve, the usual age for an apprentice to commence learning his trade.

Giovanni had written approvingly of Perugino in his chronicle: 'Leonardo da Vinci, il Perugino, Pier della Pieve, they are the divine painters.' Bartolomeo, acting *in loco parentis*, decided to foster the precocious talent by assigning him to a prestigious tutor.

Although Giovanni had founded a successful workshop and had probably given up his small providers' shop, his was not the only *bottega* in Urbino. In 1495, the year following Giovanni's death, Timoteo Viti, a native of Urbino, returned following four years' study in Bologna under Francesco Francia. Thirteen years Raphael's senior, he was immediately taken on at the ducal palace in Urbino and received several ecclesiastical commissions.

The two artists were to influence each other in style and composition and in later life Raphael was able to employ Viti in his *bottega*.

Acquaintances formed in the *botteghe* often lasted a fruitful lifetime, and the stylistic developments of the artists were shared with each other. However, all aspiring artists had to start at the bottom of a regimented ladder, which began on the floor of the workshop.

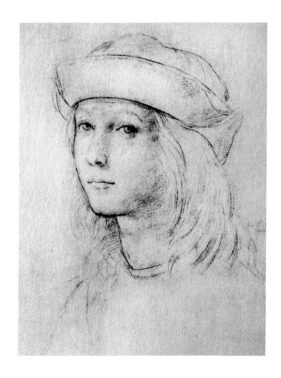

The World of the *Bottega*

The Renaissance artist was heir to centuries of exquisite art preserved in medieval manuscripts.

Raphael's first self-portrait, 1499

 The principal patrons of the arts in the medieval period were the Church and the aristocracy. These twin powers dominated art from the late Middle Ages until the sixteenth century. The production of art was expensive, not only in terms of stipends for the artists but for the materials used. Pigments, precious metals and gems were costly and a substantial partial payment was often required before work on a commission could begin.

 Decoration was part of everyday life. There was a constant demand for domestic items such as painted wooden linen or dowry chests, window shutters, doors, shields, banners and balconies, as well as religious paintings or portraits for the nobility.

As in the Roman world, work spaces were usually located on the ground floor of the family home, opening on to the street. The family lived on the upper floors. Living over a butcher or cheesemonger must have brought olfactory challenges.

The overseer of the artist's *bottega* was usually an established practitioner who employed junior assistants to prepare the materials. It was his task to search for clients or to welcome them when they approached with a proposal. The head of the *bottega* listened to their request and then channelled it into a provisional drawing for approval. Not all visitors were prospective patrons. Often a sculptor who lacked sufficient drawing skills or imagination would present himself to an overseer, the *magister*, to obtain a drawing of what he intended to chisel from stone or cast in bronze.

Architects did not formally study their skill and the boundary between architect and artist was less defined until the seventeenth century. Many builders came to a *bottega* for a ground plan for a house or church. The rest they could comfortably do with a T-square and plumb line.

The lowest rank in the *bottega* was that of pigment grinder and sand-sifter. Boys – for girls did not feature in the *botteghe* until the seventeenth century – were given the task of grinding minerals with a pestle and mortar. They usually entered the workshop in their very early teens, with some exceptions made for prepubescent children.

The artist's extended family often participated in the task of producing a painting. There are countless instances of sons following their fathers into the trade. Some tasks were menial and required little more than brawn, while others demanded skill and flair. Such apprentices spent about six years with a *magister*. The goal was to join a guild, or trade union. Membership of a guild ensured success, bringing commissions and political influence.

Most artists remained in their home towns, supplying decorative arts for whomsoever requested their services. The regular feast days and religious

processions required a constant source of painted banners and wooden structures that were erected both inside and outside the churches. Occasionally artists travelled to find commissions in other cities but, more often, they returned home to prepare the designs and produced the finished works in their *botteghe*. Preliminary drawings were done with charcoal twigs or chalk. Pens for drawing up contracts were made from quills, and sharpened with a blade as required.

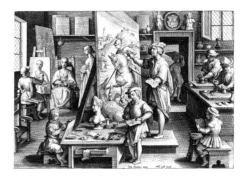

The artist's bottega

Pigments, sand and lime had to purchased, and artists had their own trusted suppliers. Brushes were made from materials ranging from rough hog to soft sable. Everyone at the *bottega* was set to work and the success of the studio depended on how well the *magister* was able to assemble and direct his team. A lawyer was also required, as contracts were often broken, either by the patron or by the *bottega*. Artists were often illiterate and depended on an honest lawyer to draw up an appropriate contract.

This may have been the path that Giovanni wished his son to take as he watched him deftly cover pages of rough paper with drawings of extraordinary delicacy and skill. Raphael's first self-portrait dates to 1499, when he was sixteen years old. Wearing an upturned cap from which his hair flows to his shoulders, the boy looks directly at the viewer, his countenance serene and confident.

Although the young Raphael came to the studio of Perugino with skills already honed in his father's workshop, only after having faithfully followed his new master would he be allowed to develop his own individual style. According to Cennino Cennini, the first and most important task of the apprentice was to learn how to imitate his master's unique style and technique.

Painting Techniques

ntil the mid-fifteenth century, there were two predominant forms of painting in western Europe. Fresco dated from more than a thousand years before Christ, and tempera had developed in the late Middle Ages. Fresco was suitable for large areas such as walls and ceilings, while tempera, which used more expensive pigments, was used for smaller works.

Fresco

Fresco, from the Italian 'fresh', involved painting onto a wet surface of plaster. The wall was prepared with two or three coats of plaster, called *arriccio*, onto which the paint was applied. The final coating was called *intonico*. The colours did not remain on the surface but travelled into the drying plaster and were sealed in as the 'skin' oxodised. Water could evaporate but could also be absorbed. Such wall paintings could only be painted in small portions; if the plaster dried too quickly it no longer served as a suitable medium but had

to be hacked away and new wet plaster applied. The artist often painted an outline of the work using *sinope*, a red pigment mined in Cappadocia since ancient times and exported to Europe through the Greek port of Sinope.

A contract memorandum dated June 1572, between Giorgio Vasari and Duke Cosimo de' Medici, gives an insight into the working of the studio undoubtedly used in Raphael's day. Vasari had been hired to fresco the interior of the dome of Florence's cathedral. For this task, he required a foreman, two *garzoni*, or young boys, to grind and mix the pigments, several manual labourers to erect the scaffolding, three expert plasterers to prepare the walls for the artists and three professional painters to depict draperies, clouds and backgrounds, each according to his speciality.

When the fresh plaster was still moist, a paper cartoon over which the life-sized image was outlined in charcoal or black chalk was prepared. The lines were pricked with holes.

When the paper was laid on the plaster, the most poorly paid assistant pounced the paper with a sponge dipped in charcoal. When the paper was peeled away, the painter had a dotted guideline to follow. Thus there could be no mistake with size or proportion. While most of the chalk lines or dots were blown away as the painting progressed, it is not uncommon for restorers to find the lines emerging. Unsurprisingly, pouncing the paper was the least popular task as the charcoal was inhaled and caused lung problems. No wonder that Michelangelo told Vasari that 'fresco painting is not an art for an old man'.

A second method was also employed. Rather than prick the lines with holes and pounce with a charcoal sponge, the cartoon was sometimes laid upon the plaster and an assistant traced the lines with a stylus. The advantage of this method was that it avoided charcoal, which occasionally dulled the pigments, but the method of line tracing could only be used in well-lit areas

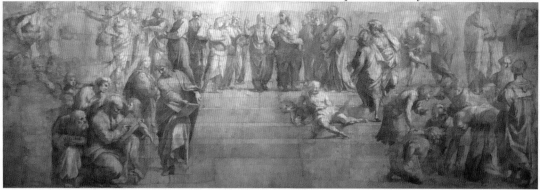

where the painter could see the incisions. Churches, libraries and refectories rarely had good lighting, so the pin-hole method remained popular.

Tempera

Tempera was applied to seasoned wood, most often oak or poplar. The surface was primed with *gesso,* a liquid plaster. The pigments were mixed in equal measure with egg yolk and vinegar, which acted as a binding agent. Some of the pigments were highly toxic. Lead was used when white was needed, while cinnabar, which contained mercury, and orpiment, which has traces of arsenic, were very popular. All were toxic and led to skin diseases or lung problems.

This form of painting was favoured for church altarpieces, as a number of panels could be painted in the *bottega* and then assembled in the church. The colours were usually sealed in by a light coat of varnish which protected the painting from pollutants and provided a lustrous sheen.

Oil

In the fifteenth century, artists changed the medium from egg to oil, prefering boiled linseed or walnut oil. The oil, which also contained resin, offered a greater depth for the suspended pigments and dried more slowly than tempera. The oil technique was developed in northern Europe during the first half of the fifteenth century, notably by Jan van Eyck, Robert Campin and Rogier van der Weyden. The advantage of oil was the deep lustre of the paint. Shadows depicted in oil were more realistic than those painted in tempera. As oil dried more slowly than tempera, the artist could make changes with ease.

The novel oil painting technique, on wooden panels, entered northern Italy. Later artists substituted canvas for the cumbersome wood, making the transport of finished oil paintings less costly. Artists were able to source pigments from the east that were largely unavailable in Italy. They experimented with the subtly changed palette and introduced new colours. As paintings became more realistic, the use of gold as a highlight died out (it was frowned upon by contemporary art theorists).

The closer the copy to the original, the better it was judged. Only when the master's style had been perfectly imitated could the pupil progress to his own original works. That moment of transition provided the precious link into the next phase of artistic development and the beginning of a new era.

The French Invasion of Italy

As Raphael studied his craft, the Italian peninsula, always volatile, was undergoing profound change. Over the centuries the former empire had been overrun by waves of invaders. Huns, Visigoths, Franks, Saracens, Normans and Spanish were regular and unwelcome intruders. When Alfonso II succeeded his father Ferdinand of Naples on his death in January 1494, King Charles VIII asserted French claims to the Neapolitan throne, intending to launch a crusade to liberate Jerusalem from Muslim occupation. In the summer of that year, he led an army, equipped with thirty-six of the latest cannon, across the Alps and into Italy. His arrival caused the northern duchies and republics to unite in a series of alliances. In January 1495, Alfonso abdicated in favour of his son, Ferdinand II, and a month later, on 20 February, Charles took Naples without bloodshed. Ferdinand fled first to the nearby island of Ischia and then on to Messina, where his cousin, another Ferdinand II, king of Sicily and Aragon, granted him asylum.

Charles had himself crowned king in Naples in May and in the early summer began his return to France through northern Italy. By then a Holy League united against the French king had been formed between Pope Alexander VI, Maximilian I, the Holy Roman Emperor, the Doge in Venice, King Ferdinand of Spain and Ludovico Sforza, the Duke of Milan. To Alexander's chagrin, de' Medici-ruled Florence refused to join the league against the French king. Charles and the allies met in battle at Fornovo. The indecisive confrontation allowed him to retreat with most of his soldiers to France.

The French invasion had shaken the Italians. The de' Medici had ruled Florence informally since the mid-fifteenth century, but by 1494 had lost most of the financial control with the collapse of several branches of their bank. The Dominican friar, Girolamo Savonarola, railed against their extravagance, urging citizens and artists to burn their vulgar works of art on bonfires in the city. Alexander VI, still smarting from Florence's refusal to join his anti-French league, urged the city fathers to silence Savonarola. In 1497 the pope excommunicated the friar. A year later the city fathers burned him to death in the city square.

Raphael was still a young man as these dramatic events unfolded. He may have heard rumours about the scandalous Alexander VI who promoted his illegitimate children to positions of power, appointing his son, Cesare, as cardinal. For a young boy, these stories may have held little interest. However, in 1494, Pope Alexander's arch-enemy Cardinal Giuliano della Rovere had entered Italy with the French king and would soon be elected pope, changing the young Raphael's career forever.

Rapahel's First Commissions

In the summer of 1499, Raphael travelled to the small town of Città di Castello, between Urbino and Perugia in northern Umbria, in the company of some members of his late father's *bottega*. He had just turned seventeen.

Paolo Uccello had succeeded Raphael's father as court painter in 1495, and had brought his own itinerant studio from Pratovecchio to Urbino. With new competition and recognising the need to find new commissions, Raphael explored opportunities beyond the limits of the city. He had inherited his father's house, and with it the *bottega* and any workers who still wanted to work within it.

Statue of Girolamo Savonarola in Ferrara

While several left to work with other masters, some remained, in the hope that Giovanni's *bottega* would survive. The number of artists already working in Città di Castello, a border town close to Florence, was a measure both of the town's prosperity and of the possibilities of finding new patrons.

The artist Luca Signorelli had worked from his native Cortona, close to Città di Castello, since 1484, and had dominated the ecclesiastical scene during the 1490s, painting five altarpieces for various churches. Raphael was struck by the sense of movement with which Signorelli imbued his figures as well as his depth of field and perspective. These contrasted with the more measured, if not staged, arrangement of figures favoured by Perugino and others. Raphael also noted Signorelli's mastery of ancient architecture, which was coming back into vogue.

In 1498, Signorelli travelled from home to begin a lucrative fresco cycle in the cloister of the Benedictine abbey of Monte Oliveto outside Siena. This created a vacuum into which the young Raphael enthusiastically stepped, accompanied by at least one senior member of his father's studio. In 1488 Signorelli had been granted citizenship in gratitude for a processional banner. In 1499, despite his youth, Raphael received a commission from the Confraternity of the Holy Trinity to paint a banner representing the Holy Trinity. It augured well for his future in the town.

Raphael's confraternity banner, commissioned following the outbreak of a plague, was a cautious work, depicting St Sebastian, the patron saint of soldiers, and St Roch, the patron of those afflicted by the plague, on one side and the Creation of Eve on the reverse. However, in the altarpieces which he began in 1500, the teenager was already showing extraordinary skill with colour and movement. His novel technique was quickly noticed by the patrons who offered him commissions for altarpieces. While the contracts stipulated the number of figures to be included in each altarpiece he was free to depict them in whatever way he wanted.

By early 1500, Raphael was in Perugia, working in the studio of the revered Perugino and participating in the decoration of the Collegio del Cambio, the city's money exchange. He seems to have painted the figures of Fortitude, Sybil, Solomon, Leonidas, Horatius and Lucius Sicinius.

In December of that year, Raphael was commissioned to paint a wooden panel, *The Coronation of Saint Nicholas of Tolentino*, for the church of San Agostino in Città di Castello. The inspiration for the panel may have been a banner painted in 1446 to celebrate the canonisation of St Nicholas by Pope Eugene IV, who had a strong devotion to the saint. Raphael worked with Evangelista da Pian di Meleto, the trusted assistant of Giovanni Santi. Although he was only seventeen, Raphael was already described as a *magister*. He set about making the cartoons for the large painting, while Evangelista may have painted the smaller *predella* panels under the altarpiece. The large altarpiece was delivered just eleven months later, on 10 September 1501. The two artists may have travelled back and forth to the *bottega* in Urbino to complete the commission.

Raphael may have stayed away from Urbino during a civil disturbance caused by Pope Alexander's illegitimate son, Cesare Borgia, who briefly took over the town in 1502. If so, he would have set up a temporary workshop in Città di Castello and continued to search for new commissions.

On 29 June 1503, the feast of St Peter and St Paul, Pinturicchio received a commission from Cardinal Francesco Todeschini Piccolomini, the archbishop of Siena. Pinturicchio was to paint frescos in the newly built library attached to the

Chapter 5
From Perugia to Florence and Back Again (1500–08)

cathedral of Siena. Piccolomini, a nephew of the deceased Pius II, wanted to house the pope's books and asked Pinturicchio to paint a series of wall frescos to commemorate the life of his illustrious relative.

Pius II had died in 1464 but construction on the library had not begun until 1492. Todeschini-Piccolomini intended the library to reflect as much glory and admiration on him as upon his famous maternal uncle. The library was inspired by the French tradition of attaching libraries to cathedrals. Only a couple of decades earlier Pope Sixtus IV had opened a magnificent library for scholars at the Vatican, a collection of priceless papyri, vellum manuscripts and printed books.

Pinturicchio summoned all the members of his workshop and divided the work between them. According to the contract, the entire surface of the four walls and ceiling of the library were to be covered with fresco.

In September of that year, Pinturicchio became unwell, so unwell that he called a notary to his house in Perugia and dictated his will. As he looked around his studio, he decided to enlist the help of the nineteen-year-old Raphael. Although the contract forbade anyone but Pinturricchio to design the chapel, the master allocated at least two frescos to Raphael. The vitality of the sketches the young artist provided must have astonished the elderly Pinturicchio, who recovered from his illness and continued his work.

The experience of the Piccolomini library and further private commissions gave Raphael great confidence. In 1503 he was commissioned by Domenico dei Gavari to paint a crucifixion for the family chapel in the Dominican church of San Domenico in Città di Castello. The painting largely reflects Perugino's style in composition and palette. The painting is divided into two halves, a technique that Raphael occassionally favoured throughout his life. In the upper register, two angels hold chalices into which blood from the side of Christ flows. The angels stand lightly on two clouds which appear in an otherwise tranquil blue sky.

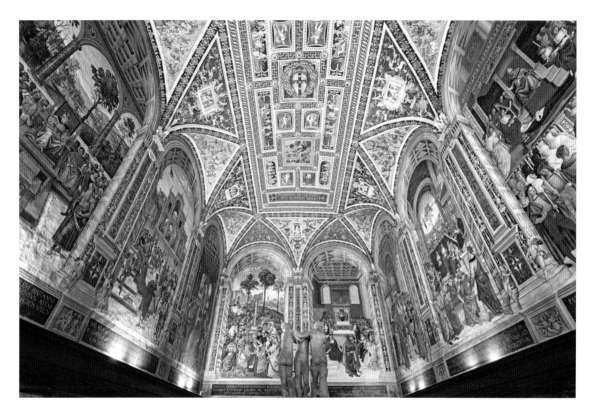

Below, four figures attend the scene with an air of contemplative detach-
ment. Mary, the mother of Christ, and St John gaze out at the viewer, while the
kneeling figures of St Jerome and St Mary Magdalene flank the dying Christ.
At the foot of the cross is Raphael's signature, his first on a work of art.

Perugino's influence on Raphael's work is seen in *The Marriage of the
Blessed Virgin*, completed by the younger artist for the Church of San Francesco
in Città di Castello in 1504. The story is not found in the Bible but in the

Golden Legend, a medieval collection of the lives of the saints. According to the legend Mary had a number of suitors. The one who could make a branch bloom would claim her hand. Joseph, alone of the suitors, was able to perform the miracle. On the upper register of the fresco there is a circular temple surrounded by an arcade, similar to Perugino's 'Christ Giving of the Keys to Saint Peter' in the Sistine Chapel. A set of paving stones underlines the use of perspective, which Raphael had mastered. In the centre of the lower register St Joseph places a ring on the figure of his bride. Behind Mary, who is wearing a rose-coloured tunic and blue mantle, there is a group of five women, while Joseph, clothed in a purple tunic and yellow cloak, is accompanied by five men. A Jewish priest joins their two hands in marriage while one of Mary's suitors breaks a rod on his knee. The foreshortened face shows acceptance rather than disappointment.

Raphael gradually moved away from Perugino's perfectly contemplative configurations. When Perugino received a commission for an altarpiece depicting the assumption and coronation of the Blessed Virgin Mary, he passed the execution to Raphael. Once more Raphael divided the work into two halves. The apostles are shown gathered around the sarcophagus of Mary, set off-centre at an angle. In the heavens, separated from the Earth by a soft carpet of cloud, Christ places a crown on Mary's head while angels accompany the scene with musical instruments. The three small *predelle* depict the Annunciation, the Nativity and the Presentation of Christ in the Temple. Each panel shows a developing mastery of perspective and figures in movement. But Raphael's depiction of sacred scenes are still other-worldly, and the viewer is invited to contemplate and pray rather than simply admire.

At this time, Raphael's work was not confined to large commissions for churches. The growing wealth of merchants and traders allowed individuals to order small paintings for domestic devotion. Patrons usually commissioned a painting of the saint after whom they were named, or images of Mary

holding the infant Christ. Raphael painted a number of popular intimate portraits of Mary holding Christ on her lap. These had the double advantage of being economical to produce and small enough to execute rapidly. Above all, they were paintings before which the family would gather to recite their daily prayers. When Duke Guidobaldo arrived back in Urbino in 1503, Raphael painted an *Agony in the Garden* and two small images of the Blessed Virgin to celebrate his return.

The Golden Legend

Two Papal Elections

Following the death of Pope Alexander VI in August 1503 thirty-nine cardinals gathered in the Apostolic Palace where they elected Cardinal Francesco Todeschini-Piccolomini as Pius III. Raphael must have rejoiced to hear the news that the cardinal who had commissioned the library at Siena had been elected pope. Piccolomini, who was too ill to attend the scrutiny at which he was elected, was a compromise candidate between the powerful Borgia and della Rovere factions. The new pope, who was a deacon, was ordained a priest and bishop immediately following his election. Raphael's joy was short-lived. Twenty-eight days after his election, Pius III died from an ulcer in the Apostolic Palace.

Thirty-eight cardinals gathered at the Apostolic Palace on 1 November 1503 to elect Pius's successor. After two scrutinies and in under ten hours, the shortest conclave in history elected Cardinal Giuliano della Rovere.

The new pope, a nephew of Sixtus IV, took the name Julius II, which some soon interpreted as a homage to the warlike Julius Caesar. Julius had detested his predecessor Alexander and was

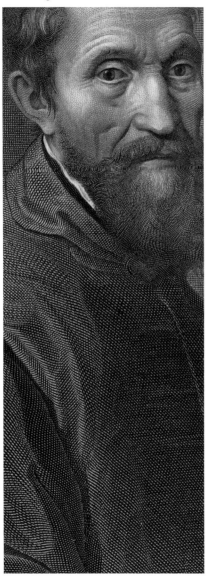

determined to exile the illegitimate Borgia children and expel 'barbarians' from Italian soil. At his coronation on 5 December 1503, seven wooden triumphal arches, similar to those erected in honour of the victorious Roman general, were erected along the processional route between Castel Sant'Angelo and the Lateran Basilica.

Julius's reign did not begin in the glory that he had intended, however, and soon he was forced to buy in grain to feed a starving populace. The population of the city was estimated to be some thirty thousand, swollen by the presence of pilgrims. As the new bishop of Rome and *pontifex maximus*, Julius was determined to restore the city to its former imperial glory and make it a worthy seat of Christendom.

Florence

In the early autumn of 1504, Raphael arrived in Florence. According to a discredited legend he carried a letter written by Giovanna Felicia Feltria della Rovere, sister of Duke Guidobaldo of Urbino. The letter was allegedly addressed to Piero Soderini, who in 1502 had been elected *gonfaloniere* and ruler of Florence. Through marriage to Dianora Tornabuoni, he had become an in-law of the de' Medici, a connection that he exploited with great diplomacy.

Soderini had recently commissioned Michelangelo to paint the Battle of Cascina in the Sala dei Cinquecento in the Palazzo Vecchio and had asked Leonardo da Vinci to paint the opposite wall with a scene from the Battle of Anghiari. Raphael knew that any introductions Soderini could effect to the gentry and rulers of Florence would be invaluable. He particularly hoped

to receive a public commission which would greatly enhance his reputation. Fully aware of his own skills, he was confident that Florence would provide the breakthrough that he had long sought.

Benedetto Dei, a banker working with the de' Medici, wrote in praise of the city of Florence around 1470. It contained 102 churches and twenty-three palaces, with fifty piazzas within the city walls. There were hundreds of small *botteghe*, for woodworkers, marble carvers, goldsmiths, silk embroiderers, sculptors, painters, ironmongers and silversmiths. For the newly arrived Raphael, Florence was a hive of activity and potential sources of lucrative commissions. Yet, barely more than a year earlier, Florence had been recovering from the upheaval caused by the Dominican friar, Savonarola and the subsequent decline following the ousting of the de' Medici. The city had been besieged by Cesare Borgia, the son of Pope Alexander VI. When Cesare died in the summer of 1507, Florence was liberated and a fresh spirit of liberty pervaded the city.

The months Raphael spent in Florence were his most formative to date. Through the generous patronage of the de' Medici and other financiers, the city had become enormously rich. Raphael admired the dome of the cathedral built by Brunelleschi, examined the bronze doors of the baptistry cast by Lorenzo Ghiberti, walked around the statues of David by Donatello and Michelangelo, gazed at the altarpieces of Fra Angelico and touched the frescos of Masaccio and Masolino in the Brancaccio chapel at the Church of Our Lady of Mount Carmel. There were myriad masterpieces by the greatest artists of the age, and from each one his keen eye learned a new technique.

Talented as Raphael was, Florence had an abundance of gifted and supremely confident artists. In *De Lapidibus* (1502), Camillo Leonardi praised artists who 'with admirable practical and theoretical strictness had set down geometrical laws of painting upon rules of arithmetic and perspective' – an art he did not think that even the ancients had achieved.

Amongst the artists praised was Leonardo da Vinci, who was thirty years Raphael's senior, and Michelangelo, just eight years older than the painter from Urbino. Both had established themselves in Florence as gifted and highly respected artists. Leonardo was celebrated for his vast range of interests, while Michelangelo was venerated as a sculptor almost without equal. When Leonardo unveiled his *Madonna and Child with St Anne* at Santissima Annunziata in 1501, there was a stampede to see the work. On 8 September 1504, Michelangelo's six-ton marble statue of David had been installed in the Piazza della Signoria. The piece of marble, called 'Il Gigante', had been left uncarved and abandoned almost thirty years earlier. It had originally been destined for the roof of the cathedral, but Botticelli and Leonardo were among those who advised the city authorities to place the statue in the piazza in front of the Palazzo della Signoria, where it could be admired by the entire population of the city.

Raphael recognised that both artists had an unparalled mastery of human anatomy. Although the dissection of corpses was strictly forbidden by the Church, both had obtained cadavers which they studied, delicately removing skin to see the workings of the muscles and anatomy beneath. In their sketchbooks, they carefully noted the mechanics of the human body. Vasari wrote in his life of Raphael that it was in Florence that he carried out his first dissections of corpses. The cadavers of paupers and prisoners were usually supplied by gravediggers in exchange for money.

Despite the growing economy and presence of patrons, there was a constant danger of over-supply. There were no fewer than sixteen or seventeen artists with the name Raphael working in Florence in the first three decades of the sixteenth century. In late May 1508, a certain Raffaello di Giovanni was paid for gilding a metal garland that had been added to Michelangelo's marble statue of David. Raphael may have thought that he should look beyond the frontiers of the republic.

By 1505, he was back in Perugia, armed with new commissions. The Poor Clare nuns of Monte Luce near Perugia asked Raphael to paint a coronation of the Virgin for their convent, advancing thirty gold ducats in respect of the payment. The twenty-two-year-old artist pocketed the money and made a preliminary draft for the sisters. The nuns were left waiting, and over fifteen years sent several letters in a vain attempt to obtain their painting. Raphael's letters of excuse, exculpation and procrastination have not survived but they could not have pleased the sisters. Raphael died before he could deliver the work.

The Baglioni Entombment

Meanwhile, another challenge came Raphael's way. In 1505, he received a letter from Atalanta Baglioni, a member of the de facto ruling family of Perugia. Atalanta asked Raphael to paint an altarpiece for the family funerary chapel in San Francesco al Prato in Perugia. Raphael was accquainted with several members of the Baglioni family and was familiar with the reason for the commission.

On 15 July 1500, Astorre Baglioni married Lavinia Colonna. She was a member of the aristocratic Roman family whose family had included Pope Martin V. During the wedding feast, a violent dispute broke out over the alleged infidelities of various members of the clan.

The drunken quarrel escalated as daggers were drawn and scores settled. Atalanta's son, Grifonetto, together with his uncle and brothers, burst into the bridal chamber and hacked the young groom to death.

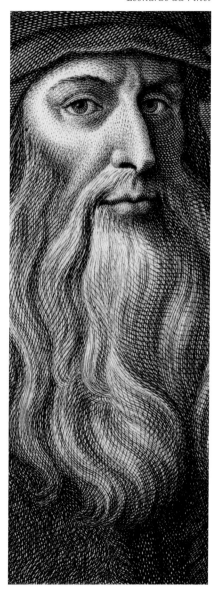

The Baglioni Entombment

By dawn over 200 bodies lay strewn around the palazzo and surrounding streets. When Grifonetto sought refuge at his mother's house, the terrified Atalanta refused to open the door. As she watched him retreat into the piazza, she saw him struck down by another relative. Running to her son, she caught him up in her arms. According to conflicting reports, the distracted mother either urged him to beg God's forgiveness for his crime or cursed his soul to hell. In one account, the mother forced her dying son to forgive his kinsfolk to bring an end to the internecine warfare.

The story had almost turned into legend by the time Raphael was summoned to meet Atalanta Baglioni. His first suggestion was to paint a depostion of Christ from the cross, but in later preparatory drawings for the distraught mother, Raphael showed the dead Christ being brought to the tomb. In the second version, Raphael shows the funerary procession in the foreground. At the centre, a young man grasps the legs of the dead Christ and helps carry the body towards the tomb. Mary swoons as the other mourners look on in shock. The young man bears the unmistakable features and hair of Grifonetto. The painting was completed in 1507.

eanwhile, in mid-1505, Julius II summoned Michelangelo to Rome to discuss a project close to the pope's heart. Although only in the second year of his pontificate, he was already constructing a *renovatio imperii* and thinking of his legacy. Combining a vision of the possible with that of the achievable, Julius appointed Bramante to oversee his new vision at Rome. He meant to sweep away the slums, lay out straight streets and build two new bridges. One would be named after his pontifical uncle Sixtus, while the other would be named after himself. Julius commissioned Michelangelo to make a funerary monument of some forty marble statues for the new basilica, which Nicholas V had dreamed of and which Julius now intended to build.

In February 1506, a farmer, Felice de Fredis, was working in a vineyard near the Esquiline Hill close to the Colosseum. His shovel struck a piece of white stone that turned out to be a marble statue. Pope Julius, whose titular church of St Peter in Chains was nearby, heard of the find and sent the architect Antonio da Sangallo to examine it. Michelangelo happened to be in Sangallo's house when the papal emissaries arrived and he accompanied the sculptor to the vineyard. Sangallo immediately identified the piece as the mythical priest Laocoon, whose fame was recounted in the accounts of the Trojan War.

The pope ordered the statue to be brought to the Vatican. It was washed in milk and the earth was cleaned from the surfaces. It was then loaded onto a cart and hung with garlands of flowers. As the church bells rang across the centre of Rome, the vast statue of the high priest and his sons was brought to the Vatican. The pope was enchanted by the monumental carving

Chapter 6
The Renewal of Rome and the Restoration of the Papal States

The Laocoon

Bramante

Donato Bramante, a native of Urbino, moved to Rome in 1499 and was favourably received by Pope Alexander VI. The Spanish pope granted him the title of sub-architect and awarded him a small pension. One of Bramante's first works was a round church on the Janiculum hill where tradition claimed that St Peter had been martyred in the first century. The circular temple or *Tempietto*, built in 1502, excited great interest in the city, where such shapes had not been built since antiquity.

While Julius wanted to renew Rome, his first wish was to aggrandise the papal residence where the popes had resided for eighty-five years. At his first audience with the new pope, Bramante was entrusted with the task of renewing the city in line with the vision of Julius's uncle, Sixtus IV. Although Julius may have known Bramante by virtue of some of his works, the connection with Urbino also played a part in his entering into papal service.

Bramante was already steeped in the architecture of ancient Rome and had skilfully mastered the mechanics of masonry. The difficulty was choosing a starting point, an inconvenience Julius quickly resolved by ordering him to build a palace built around a courtyard in front of the Apostolic Palace. The vast Belvedere Courtyard, named for the fine view it offered of the countryside north of the city, was some 300 metres long. Its very size inspired awe in those who saw it rise, while the classical sculptures that Julius installed gained widespread admiration.

Julius then set up a competition to find an architect to undertake the construction of the new basilica. Among the applicants were Giuliano da Sangallo and a Franciscan friar, Fra Giovanni Giocondo. Julius appointed no judges but decided to award the project based on his own wishes. Bramante won the competition, and was commissioned to build the new basilica.

The new plan required the demolition in sections of the Constantinian basilica. The pope refused to close the shrine, insisting that pilgrims be allowed continuous access throughout the demolition process. As a result, some Roman wags dubbed Bramante 'Maestro Ruinante', or master destroyer.

As a further proof of his esteem and his ambitions for a new basilica, Julius requested plans from Bramante for a new papal residence. However, he was preoccupied by the need to subdue the rebel towns within the papal territories and unable to decide whether to move to the former seat of the papacy at the Lateran or remain at St Peter's, so the plans came to nothing.

Facing page: Bramante's Tempietto

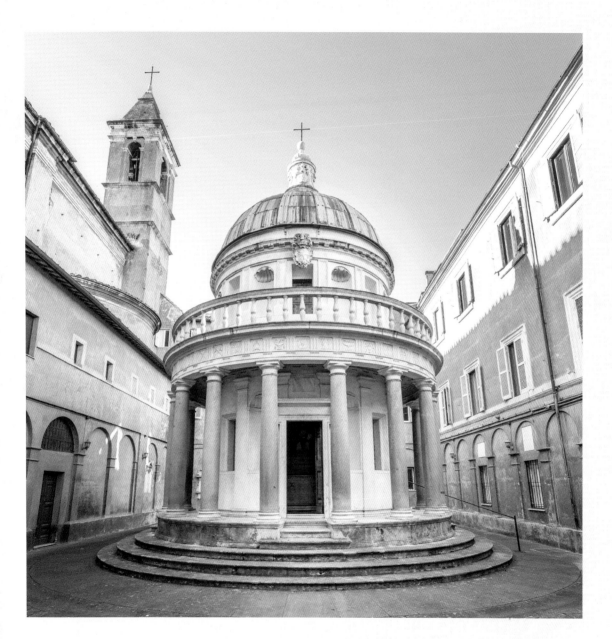

and installed it in the octagonal courtyard close to the Apostolic Palace. It was the most impressive sculpture so far to emerge from the Roman *tufo*.

St Peter's Basilica

The majority of popes were buried in St Peter's Basilica, and Julius had already chosen a chapel for his tomb. The scale of the proposed sarcophagus, however, had never been seen before. The pope contracted Michelangelo to provide a marble monument with forty statues and several bronze bas-reliefs. In the event of his own demise, Julius arranged that the monument would be paid for from his estate. Michelangelo travelled to the quarry of Carrara overlooking the Tuscan coast and spent several weeks choosing the marble needed to commence the work. In November, some 34,000 kilos of marble were delivered to Michelangelo's Roman workshop.

While Michelangelo was pleased to enjoy the new pope's confidence, the prestige of the commission soon wore off. The monument would not be finished until 1545, in a vastly reduced form, and the venue was changed to the Church of St Peter in Chains. Michelangelo grumbled constantly about the volatile pope and his unreasonable requests.

While debating the placement of his tomb in St Peter's, Julius came to a formidable decision. Nicholas V had wanted to build a new St Peter's Basilica and had failed. Now, Julius would bring the project to a worthy finish.

On Easter Sunday, 18 April 1506, the pope laid the foundation stone for the new basilica. The bells tolled as the pope read the Latin formula for the commencement of a new church. The courtiers gathered around the hole that had been dug in the earth and wondered how long the enterprise would take. As they watched Julius clamber down a stepladder to bless the stone, they knew that neither they nor the pope would live to see the dedication of the new basilica.

The rebuilding of St Peter's had an enormous impact on Christians and, in particular, the artists of the Italian peninsula. As soon as the walls began to

rise and a roof was placed over the naves, the quest for artists would begin in earnest. No one could guess that the enterprise would take so long, demand the skills of seven architects, and would not be consecrated for a further 120 years. As Julius authorised the sale of indulgences in 1507 to support the rebuilding of the tomb of the apostles, he unwittingly supplied the pivotal point that would lead to the Reformation just a decade later.

The atmosphere in Rome remained enthusiastic. The ebullient pope was clearly determined to make the city shine once more as the *caput mundi*. But all of this construction required money and that was something that the papacy was rapidly haemorrhaging. Wealth was slowly coming from the New World in the form of gold and gems, but it was insufficient to fund Julius's ambitious plans.

The Campaign to Retrieve the Papal States

The pope was determined to restore the Papal States and to wrest control from Venice and a number of families that had usurped them. His ire was directed principally towards the Baglioni of Perugia and the Bentivogli of Bologna. A year after his election, he wrote to the Doge and senate in Venice, demanding the withdrawal of the Serene Republic from a number of towns on the northeast of the peninsula.

Julius could only blame his predecessors, the seven French popes who had refused to reside in Rome. For three quarters of the fourteenth century, the papal court had been camped along the banks of the River Rhône, where two palaces were built to house the pontiffs and their expanding band of courtiers and curial members. There was a constant procession of cardinals and ambassadors. Candlemakers, tailors, cobblers, carpenters, prostitutes and artists all clustered around the soaring papal palace. As the papacy settled into the soft fields and gentle hills of Provence, the prospect of a return to the lawlessness of Rome seemed ever further away. Life was assuredly more

tranquil in the rolling green landscape than in the fractious atmosphere of the capital of the ancient world.

While the popes lived in France, pilgrims no longer travelled along the Via Francigena, the ancient route joining Canturbury to Rome, and over whose cobblestones thousands passed each day.

Julius was determined to restore the patrimony of St Peter. The coffers, further emptied by the rapacious members of the Borgia family of Alexander VI, would be filled once more. By sword or by word, Julius was decided.

The pope's diplomatic overtures were unsuccessful. Indignant at the arrogance of the Baglioni and Bentivolgi families' refusal to vacate the holdings that they had usurped, Julius threatened military action. They ignored him. Julius issued a final ultimatum in the summer of 1506 and, by August, he had amassed an army and was ready for war.

Julius was too shrewd to march alone against the usurpers. He had courted the king of France, Louis and the Sforza of Milan, who resented the growing power of Venice and readily joined forces in the League of Cambrai. The papal soldiers, mostly mercenary *condottieri*, set off from Rome in early September. Papal ambassadors had been sent ahead to warn the cities of the army's advance and to entreat them to agree to a peaceful surrender.

The first part of the march went well for the papal troops. On 13 September, the pope entered Perugia, demanding the submission of the Baglioni and their allies. The request was a mere formality as the Baglioni had already capitulated and workmen had hastily erected a wooden triumphal arch made from the props used at religious festivals throughout the year. On 15 September, having received the promise that Perugia would obey the pope, Julius moved on to Urbino, taking advantage of the duke's offer of support and food for the army. The duke, Julius's nephew, Francesco Maria della Rovere, broadly supported Venice, but Julius was determined to restore the Papal States in their entirety to the Church.

lorence was the most important city for artists in the sixteenth century. Rich merchants and generous patrons were willing to spend enormous amounts on the decoration of their homes and churches. In the late summer of 1506 Michelangelo was busy in the Palazzo della Signora, preparing a fresco of a battle scene. Raphael had visited Florence during the period and saw the Florentine's preparatory drawings. He was greatly impressed by the energy and command of anatomy, and he incorporated Michelangelo's style into his own figurative work.

Raphael had soon made influential contacts in Florence, and, following the death of Duke Guidobaldo on 10 April 1508, he wrote to his uncle, Simone Ciarla, asking him to assist him with some domestic matters. He requested that he meet his friend, Florentine banker Taddeo Taddei, who would be attending the duke's obsequies. Raphael thought it would be a diplomatic gesture for his two uncles, both priests, and his aunt, to meet the financier who was a patron of Michelangelo and had also commissioned Raphael to carry out some work.

In the early part of 1508 Raphael was busy with two important Florentine commissions. The first, a Madonna and child destined for the audience hall in the Palazzo Vecchio, was delivered in July. The second work was a large canvas depicting the Madonna seated under an elaborate *baldacchino*. This work was the fulfilment of a bequest from Bernardo Dei, a successful goldsmith, who requested a painting and some liturgical items for the family chapel in the church of Santo Spirito. As Raphael explained to his uncle Simone in his July letter, he and his assistants would finish the cartoon towards the end of April

Chapter 7
From Florence to Rome (1508–13) – the Patronage of Pope Julius II

and he was confident of other lucrative contracts coming his way. However, he also asked his uncle if he could obtain a letter of recommendation from Piero Soderini to paint a 'stanza', although he did not identify where the room might be.

Raphael had not got far with the Dei commission when, in mid-summer, the opportunity came to visit Rome. The influential painter, architect, writer and historian, Giorgio Vasari, later claimed that Bramante, a native of Urbino and perhaps a distant relative, had put in a good word for Raphael with Pope Julius. The pope had already seen Raphael's altarpieces in Perugia and was certainly aware of the young man's talent. During his Roman sojourn, Raphael must have seen what an opportunity working at the papal court would be. He abandoned the Dei altarpiece, which remained unfinished in his lifetime and was brought to completion by Rosso Fiorentino two decades later.

Rome

At the papal court, Raphael would receive extravagant commissions beyond his dreams and find himself stretched to his artistic and physical limits. In Rome, he would climb to new heights, making influential contacts with bankers and aristocrats who would soon vie for his art.

The summer heat was over and Pope Julius had returned from his travels. All visitors to the Vatican had to make their way through narrow medieval streets, crowded with pilgrims speaking a variety of languages. The warren of buildings included hostels and taverns where pilgrims could rest. The early morning air was warmed by the bakers' ovens and fruit and vegetable sellers laid out their wares for the travellers. These smells mingled with those of the chamber pots emptied from the upper stories. The streets were always full of hawkers who sold tiny crucifixes or images of the saints. For the wealthier pilgrims there was a ready supply of pickpockets to relieve them of their valuables.

Bronze pine cone formerly in the fountain of the courtyard of old St Peter's, now in the Bramante Courtyard

The wide rectangular courtyard in front of St Peter's was always crowded with pilgrims. A large bronze pine cone from ancient times stood in a fountain at the centre. Although severely dilapidated, the first impression on a visitor from northern Europe must have been almost miraculous. Not even the most lavish church in Bavaria could compare with a chapel in St Peter's. Scaffolding had already been raised around the choir as Bramante's workmen carved and chiselled the new basilica.

Julius lived in the part of the Apostolic Palace built on three stories by Nicholas V in the mid-fifteenth century. Less than two years after his election, he moved out of his apartments, complaining that they reminded him of his odious predeccessor, Alexander VI. During his absence the papal apartments, including a small bedroom, bathroom, dressing room and chapel, were renovated by a team of artists that comprised Balduino and Cesare da Sesto, Giuliano Sangallo, Baldinus de Baldinus, Raniero da Pisa, Michele del Becca and Cesare Jacob of Milan. Having completed his first military campaign, Julius turned his attention once more to decorating his chosen private apartments.

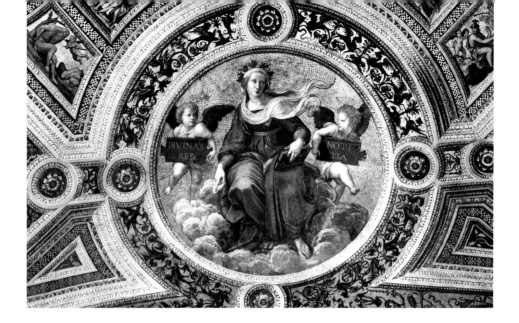

One of Il Sodoma's four ceiling spandrels in the Stanza della Segnatura

The Stanza della Segnatura

Julius decided to start with the papal library, which served as a reception room for meetings when he wished to impress his visitors, and to sign and seal important documents. A series of wooden bookcases housed his collection of 220 books, most of which dealt with theology and Church law. The pope asked Raphael to paint a test piece, a figure of God the Father. Pleased with the result, he gave him the commission to paint the wall.

Raphael was not given free rein. When he arrived, he found Antonio Bazzi, known to his contemporaries as Il Sodoma, because of his supposed sexual interests, already painting the ceiling. Baldassare Peruzzi, Timoteo Viti and and Lorenzo Lotto were at work in the adjacent rooms. As the pope examined Raphael's preparatory drawings and watched him work, he dismissed the other artists and entrusted the entire decorative scheme to Raphael's *bottega*. Out of deference to Il Sodoma, whose work he admired, Raphael retained the four ceiling spandrels.

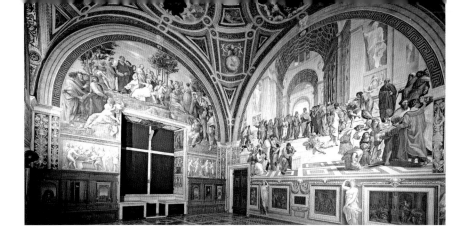

Two of Raphael's walls in the Stanza della Segnatura: Mount Parnassus (left) and School of Athens (right)

Egidio of Viterbo, one of Julius's favoured preachers and advisers, had helped Michelangelo lay out the plan of his celebrated ceiling and he now offered suggestions for Raphael's design. The papal librarian, Tommaso Inghirami, a close friend of Raphael's for many years, discussed the outline of the overall design of the room. Inghirami was an amusing flirt, catching the eyes of Raphael's *garzoni* as they ground their pigments or scaled the ladders to deliver fresh plaster for the *buon fresco.* An inveterate racconteur with a scholar's penchant for gossip, Inghirami was also acclaimed as an actor with a prodigious memory. The room was a lively place when Inghirami was around to dispense his advice.

Two facing walls were devoted to secular wisdom and divine knowledge. The philosophy of Greece and Rome and the theology of the Church were painted on the remaining two walls. The documents recording which wall Raphael started on and when he completed each have been destroyed.

As with his previous paintings in Perugia, the work is laid out on two planes. God, surrounded by his angels and saints in heaven, is lauded by the theologians who elucidated the faith. On the second wall, Raphael depicted Aristotle, Plato and the other great philosophers of antiquity. Plato points to the immaterial concepts in the sky while Aristotle indicates the world of experience below. The rest of the wall features some fifty philosophers and

thinkers. On the smaller lateral walls, which have four window openings, law is depicted in the fresco of *Justice*, while poetry is laid out in *Parnassus*. On these two walls, Raphael painted several women. He painted a celebrated prostitute, Imperia Cognati, as the poetess Lesbos, provoking wry smiles among the courtiers.

By showing Julius as a patron of the philosophy of the ancients, Raphael sanctified the pagans. By representing the great thinkers of pre-Christian antiquity, he showed that theology was the natural result. The papacy, as custodian of the pagan past and Christian present, was seen to enjoy divine protection. Word of the elegant, well-mannered painter who had caught the pope's attention soon spread throughout cultivated circles.

To the amusement of many in the papal court, Raphael portrayed some of its members in the guise of the ancients. His depiction of Euclid is clearly a tribute to Bramante, and around the collar Raphael signed the work RUSM, *Rafaello Urbinas Sua Mano*, by the hand of Raphael of Urbino. As a visual tribute, Raphael depicted a smiling Pope Gregory the Great with the features of Julius. With supreme self-confidence, he also included his self-portrait, smiling down at the viewers below.

Although he had studied theology for ordination, Julius had only rudimentary Latin and little Greek. Michelangelo's biographer, Ascanio Condivi, related a conversation between the pope and sculptor after the submission of Bologna to the papal army. Julius wanted a statue of himself to commemorate the victory. When Michelangelo asked if he wanted to be depicted holding a book, Julius replied, 'A sword – I know nothing of letters'.

When the wall and ceiling frescos in the papal library were finished, the Franciscan friar, Giovanni da Verona, was summoned to make inlaid cabinets and chairs. The cabinet doors, inlaid with slivers of variously coloured wood, gave the optical illusion of depth and ingenious perspective. The designs, which may have been made by Raphael, although this is not certain, have

perished, and the cabinets themselves were destroyed during the Sack of Rome in 1527.

Raphael's presence in the city was quickly noted. In 1509, the guild of goldsmiths commissioned him to provide a design for their new church. The guild had just been formed from the guild of ironworkers. The goldsmiths had split with those who worked in base metals, claiming that their own craft was superior. Raphael, whose cousin was a goldsmith and may have helped him obtain the commission, provided the drawing for the church. However, as the site for the church was close to the Tiber in an area prone to flooding, it was sold soon afterwards.

War with the North

As Raphael worked at the Vatican, Julius was preparing for another campaign. Although the papal apartments were important to the pope, of far greater concern was the manner in which the Venetians ignored his temporal authority. He sent imperious missives to the Venetians condemning them for filling the episcopal see of Vicenza near Venice without his approval. He gathered together a group of allies, the Holy Roman Emperor, Maximilian I, Louis XII of France and Ferdinand of Aragon, and on 10 December 1508, they entered an alliance, the League of Cambrai. The terms were breathtaking in their arrogance. The Venetian republic was to be dissolved, with its territories divided between France, Spain, the emperor and the pope. Julius confidently placed himself at the head of the league.

The alliance army moved on the Venetian territories in early 1509, and had rapid success. The French king and the emperor cared nothing for episcopal sees or who occupied them, only wanting to exploit the crack in Venetian rule and gain whatever economical and political advantage they could. As the year progressed there were fierce battles throughout the Venetian territories but, within months, the senate sent an embassy to Rome to sue for peace.

DE IVLIO.II.PONT.MAX.ORBEM CHRISTIA NVM IN ARMA CONCITANTE.

Pope Julius II in armour exhorting Emperor Maximilian, King Louis XII of France and King Ferdinand of Aragon to go to war on Venice

Julius imposed strict sanctions, insisting that the Venetians pay for the cost of the war and relinquish jurisdiction over the clergy of the region. In February 1510, the Venetian ambassadors signed a submission before Julius's delegates.

By now, Julius had broken his alliance with France, protesting that Louis had not supported the aims of the military campaign. In private, he was concerned at the growing influence of the French in Italy. He suggested to the Venetian ambassador that Venice join a new alliance with him against France. The Venetians, also concerned at the French monarch's progress, agreed to enter into a holy league with the pope who, until weeks earlier, had been their enemy.

Julius was irate with Alfonso d'Este, the Duke of Ferarra. The city belonged to the Papal States, yet the duke ruled without reference to the pope. Alfonso had married Lucrezia Borgia, the illegitimate daughter of Alexander VI, an alliance that had brought with it a virtual monopoly on all trade in Ferarra. Julius refused to allow this concession to continue and demanded that Alfonso return taxes to the papal coffers at Castel Sant'Angelo.

In the late summer the pope announced his intention to march on Ferarra, setting off on a northern campaign in September 1510. He expected the progress to be similar to that made four years earlier, when his bloodless march had led to the liberation of the cities that he wanted. Julius insisted that the entire papal court accompany him to witness the rescue of the Papal States. The elderly cardinals were aghast when the pope demanded that they accompany him on the journey and live in tents.

The northern campaign of 1506/7 had been a series of bloodless victories. This campaign was dramatically different. A cold and wet autumn slowed the progress of the papal army and its entourage, which arrived in Bologna in October 1510. The Bolognese had bitter memories of Julius's last visit in 1506. On that occasion he had commissioned Michelangelo to cast a monumental

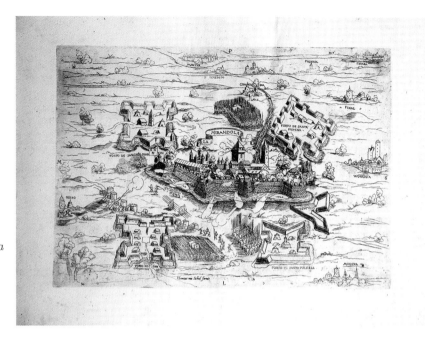

Siege of the citadel of Mirandola

bronze statue to be be placed on the facade of the cathedral of San Petronio. The sculptor laboured for two years on the work but left Bologna for Rome before the statue was placed on its plinth. The Bolognese had delayed finishing the marble plinth for a further year.

On 10 December 1510 Julius ordered the siege of the citadel of Mirandola. Days of snow had buried the town and the land outside the town walls. The pope visited the encampments dressed in armour to encourage the soldiers. To the surprise of the mercenaries, he had grown a beard, vowing not to shave until Ferarra had surrendered. He took charge of the siege, which had been in the hands of his nephew, Francesco Mario della Rovere, the Duke of Urbino. On 17 January 1511, the pope ordered the bombardment of Mirandola, directing the military operations from the kitchen of the convent of Santa Giustina. Within four days, the damaged city surrendered. The pope now turned his attention to subduing Ferrara.

The papal plan suddenly unravelled. The northerners were better prepared for a belligerent pope and refused to bow to his threats. In May, Julius moved to Ravenna whence he summoned Francesco Mario delle Rovere, and Cardinal Francesco Alidosi, the bishop of Pavia and papal treasurer, to explain why they had not supported his campaign. The duke and cardinal arrived in Ravenna at the end of May. A man of callous cruelty and guilty of murder, Alidosi had twice been accused of treason by the Duke of Urbino. The cardinal managed to convince the pope of his innocence and was absolved of any crime. The duke's resentment came to a head when he met the cardinal entering the Benedictine monastery where the pope resided. According to conflicting reports, either the duke or a groomsman knocked the cardinal from his mule and bludgeoned him to death. Although Alidosi was detested, the murder of a cardinal was a crime Julius could not forgive. Having celebrated the obsequies, the infuriated pope departed for Rome. He had lost his appetite for conquest.

The Pope's Return to Rome

On 26 June 1511, Julius arrived back in the city in a summer thunderstorm. As in the days of the Roman empire, a triumphal arch was erected at the Flaminian Gate where the crowds gathered to welcome the return of the papal court. Drummers and standard-bearers led the procession, the young men throwing their silk banners in the air before lunging to catch them as they fell to the ground. The pope, wearing his armour, sat astride a white charger, acknowledging the cheers of the Roman crowd. Whatever the feelings of the Romans about the pope and his war, most simply welcomed the return of the court and the resumption of the commerce to which the court and pilgrims gave rise. Julius, for his part, did not reveal that the military expedition had largely failed in its objective. Just a month earlier, on 22 May, Bologna had fallen into the hands of his enemies. Back in Rome,

Facing page: The Sistine Chapel

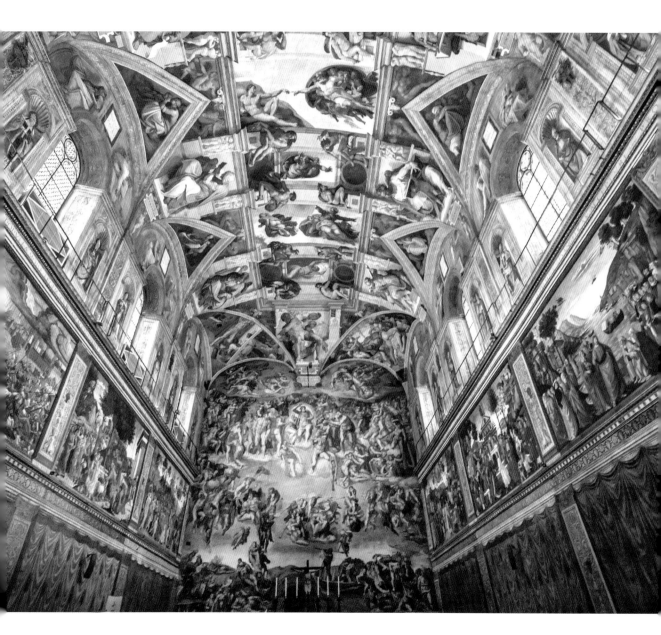

he now looked for an opportunity to convince the ambassadors that he was still in command of the Church.

Shortly after the pope's return to Rome, Raphael was summoned by the eighty-year-old papal chancellor, Sigismondo de Conti, who commissioned an altarpiece for the Church of Santa Maria in Ara Coeli overlooking the forum. The painting depicts the Madonna and child surounded by a golden disc. St John the Baptist and St Francis of Assisi, to whom Santa Maria was entrusted, flank the Virgin, while St Jerome presents the kneeling figure of Sigismondo. De Conti did not have time to enjoy the completed work. He died the following year and was buried in the family chapel close to the canvas.

Julius was impatient with what he regarded as Michelangelo's procrastination and was anxious to see what progress the artist had made on the Sistine ceiling in his absence. He harangued Michelangelo, threatening him with various sanctions to speed up his progress. The artist parried Julius's jibes as best he could. At the very commencement of the project he had protested that he was a sculptor rather than a painter. However, Julius was aware from his emissaries that Michelangelo was also a talented painter. What both men had miscalculated was the time painting with an arched back would require. Michelangelo lamented that his clothes were splattered with lime and that his face was covered with the paint that dripped from his perpendicular brush. He even drew a droll cartoon of himself, crouching below the ceiling and dabbing on the colours. As the light faded, Michelangelo lit candles on his broad-brimmed hat so that he could continue to work after sunset. A commission that he had hoped to finish in a couple of years was stretching out beyond everyone's expectations.

The pope had already seen parts of the vault at close quarters. In his biography of Michelangelo, Condivi recounted how the pontiff had climbed the scaffold to inspect progress. Julius saw no reason why Michelangelo could not work more quickly to produce the required work.

In early July, the pope told his master of ceremonies, Paride de Grassi, that he would celebrate pontifical High Mass for the Feast of the Assumption on 15 August at the main altar. This would also be the anniversary of the dedication of the chapel by his uncle at which he had assisted in 1483. De Grassi informed Michelangelo that the scaffold would have to come down in order to facilitate the ceremonies. A year earlier, Michelangelo had agreed to unveil that half portion of the vault that he had completed but the pope's absence in the north meant that the unveiling had not taken place.

On the eve of the feast day, the chapel was packed with cardinals, bishops, prelates, ambassadors and guests who had managed to get a precious invitation to the pontifical vespers. The *cappella maggiore* was a colourful scene. Clerics, richly clad in watered silk, and diplomats from the courts of Italy and Europe, dressed in satin and Egyptian cotton, gathered below the fresco depicting the creation and salvation of the world. As the pope entered the chapel, vested in a gold-embroidered cope of ivory silk and wearing a three-tiered crown on his head, he paused on the marble threshold to look up at the brightly coloured ceiling for the first time. It seemed as if the painted blue sky, decorated with golden stars, had given way to a celestial vision of the creation of the world. Raphael may also have found his way into the chapel and, as the choir intoned the psalms, his gaze would have roved around the vaulted ceiling of the chapel, now shimmering with the newly revealed colours.

Raphael's favour at the papal court was further evidenced when, on 4 October that year, Julius appointed him *scriptor brevium*, composer of papal briefs, a sinecure which gave him a place within the Roman Curia and an extra income and pension for life. Survival and progress at the papal court depended on connections. As Raphael looked around, he may have saluted a growing number of friends and courtiers with whom he was acquainted. Among them was Tommaso Inghirami, whose portrait in oil Raphael had painted two years earlier and whom he had painted as Epicurius in the papal library fresco.

Also in the congregation was Agostino Chigi, a prominent Sienese banker whose close ties to the papacy would soon bring new opportunities for Raphael. While the pope was away on his campaign in the north, Chigi had approached Raphael to paint a fresco in his newly constructed villa. Close to the sanctuary sat Bernardo di Dovizi, who had been educated at the court of the de' Medici in Florence and would soon become a cardinal and treasurer of the Church. Dovizi had already noted Raphael's talent and was curious to see how the artist's career would develop in the corridors of the Curia. He would shortly offer the hand of a relative in marriage to Raphael. Among the cardinals closest to the pope Raphael would have seen the papal nephew, Giulio de' Medici, who would ascend the papal throne twelve years later as Clement VII. A word from any of these patrons could smooth Raphael's path or rapidly finish his career.

Raphael could never take papal patronage for granted in the highly competitive atmosphere of the court. While Julius lived, he was confident of his favour, but, like all who depended on the papal munificence, he couldn't foresee what might come in the next pontificate. There were many artists courting ecclesiastical patrons, including Michelangelo, Sebastiano del Piombo, Giulio Romano, Baccio Bandinelli, Giovanni da Udine, Giulio Romano and Benvenuto Cellini. Giulio Romano and Giovanni da Udine worked as Raphael's principal assistants, but there was always a risk that they might leave to found their own workshops. Raphael increasingly entrusted his initial designs to be executed by his closest companions. He chose the artists who would work in his studio, and they were all obliged to work to his designs.

Shortly after viewing the section of Michelangelo's painted vault, Raphael returned to the pope's library, completed more than a year earlier. In the course of a single day, he added a fifty-sixth figure, seated in front of Plato and Aristotle. As Raphael had previously included the faces of several members of the papal court, he now added one immediately recognisable by his tousled

black hair, flat nose and disgruntled countenance. Viewers thought that this represented the Greek thinker Heraclitus of Ephesus. Raphael may have been playing a visual joke, for the philosopher wore contemporary leather boots. Michelangelo had suffered a broken nose in a fight some years earlier and was known for not taking off his boots for weeks at a time. It may have been a compliment, but one that must have raised a few eyebrows in the circle of courtiers and perhaps even a smile from the irascible Pope Julius.

Following a visit to Urbino in 1506, Baldassare Castiglione wrote a pen picture of the ideal courtier. Although *The Book of the Courtier* was not published for a further two decades, his literary portrait of the perfect gentleman was familiar to Raphael. Castiglione, a close friend of the artist's, explained in his preface that he wrote the book as 'a picture of of the Court of Urbino, not by the hand of Raphael or Michelangelo, but of a humble painter, who knows only how to trace the chief lines, and cannot adorn the truth with bright colouring'.

Raphael was a shrewd businessman and showed his acumen in 1511 when he met a Bolognese engraver, Marcantonio Raimondi. Raphael was familiar with the great German artist, Albrecht Dürer, and he was flattered when Dürer, twelve years his senior, sent him a self-portrait as a gift. He had responded with a set of drawings. He was fascinated to become aware of Dürer's talent as an engraver, and further impressed to learn how lucrative the art form could be. He entered into a partnership with Raimondi, who, over the next decade, made engravings of some of Raphael's most important works. This had the effect of further enhancing his reputation within the Italian states and beyond the Alps.

Pope Julius declared himself pleased with the overall effect of Michelangelo's ceiling, although he continued to chafe at the inordinate delay in bringing it to a conclusion. According to Condivi, Raphael offered, through Bramante, to finish the work. He had concluded the Stanza della Segnatura,

the Papal Library, in a little over two years, within the contractual period. The four walls and ceiling of the large room were covered in pristine fresco and had won the approval both of the pope and the members of the papal court and ambassadors who had access to them. However, Raphael realised that in finishing Michelangelo's ceiling his work would be viewed by numbers far in excess of those who entered the pope's private apartments. Word of Raphael's offer reached Michelangelo, who furiously rebuked the upstart who would dare wrest the commission from him and complained that Bramante had done nothing but insult him.

There are few contemporary accounts of how Leonardo, Michelangelo and Raphael interacted. Leonardo was more interested in engineering and design than in painting, while Michelangelo always claimed that his talent was for sculpture. For his part, Raphael absorbed the fluid energy and *contraposto* that marked the paintings of the two Florentine artists.

Portrait of a Pope

The pope had had no intention of giving the Sistine commission to Raphael. Instead, he authorised him to undertake the decoration of the room adjacent to the Stanza della Segnatura. Before that, however, the artist was called upon to paint an oil portrait of the pontiff. Raphael's portrait of Julius was one of his most extraordinary paintings of a pope and would influence papal portraiture for centuries to come. The portrait was commissioned to hang in the sacristy of Santa Maria del Popolo close to the Flaminian gate. Given Agostino Chigi's connection with the church, it is possible that he was the patron of the portrait.

Julius was acutely aware of his image and during his pontificate had more medallions bearing his profile struck than all the popes before him. The half-bust portrait was in fashion and Raphael had painted a number of likenesses that had captured the attention of his circle of admirers. Chief of these was

a pair of portraits made for a husband and wife, Agnolo and Maddalena Doni, members of a wealthy Florentine merchant family. The faces were perfect likenesses and the treatment of the rich fabrics and jewellery was astonishingly realistic. A year or two earlier Raphael had painted a portrait of a cardinal, which was admired not only for the facial features but also for the extraordinary treatment of the scarlet mozzetta, which was so real that people touched the work to see if the fabric was real silk. Papal portraits hitherto had shown the pope in profile, as befitting a ruler. Raphael's portrait gave the viewer an insight into the mind of *il papa terribile*.

Julius, a red ermine-lined velvet mozzetta over his shoulders and a camauro on his head, is seated on a thone. The brass finials depict two acorns, the symbol of the della Rovere family. The pope is fatigued, his cheeks sunken, his eyelids drooping. His beard mirrors the closely pleated rochet of fine cotton. The educated viewer could identify the white handkerchef in the pope's hand as the maniple with which the emperors of old commenced the gladitorial games.

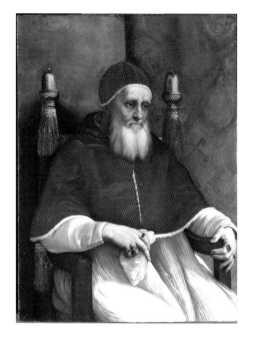

Portrait of Pope Julius II *by Raphael*

The pope stares reflectively towards the ground, his mind clearly occupied by grave matters. The portrait was not designed to flatter. Every line and crease of the face is depicted in the minutest detail and the viewer can see where the barber had just trimmed the pope's eyebrows. This is a man lost in thought, his pensive expression hiding myriad concerns.

Indeed, Julius had several cares on his mind. At his election in 1503 he had vowed to convene an ecumenical council. Such gatherings of bishops had been common since the first council called by the emperor Constantine in Nicea in

325. Julius, knowing that it would raise difficult questions about his rule, had put off the convocation for as long as possible. On 28 May 1511, in order to force his hand, four cardinals convened a council at Pisa. Julius was furious and protested that he had needed time to restore the Papal States to allow the Roman Church to function in freedom. In July that year he reluctantly convened a council to be held at the Lateran basilica.

In early January 1512, word reached the papal court that a week earlier, on 30 December, the Bolognese had pulled Michelangelo's bronze statue of Julius from its plinth on the facade of the Cathedral of San Petronio. To the pope's fury and the Duke of Ferrara's amusement, the bronze was melted down to make cannon for the army of Ferarra and the leftovers were sold for scrap.

When the council opened on 3 May 1512, fifteen cardinals and scores of bishops and theologians attended. The session restored Julius's authority and put paid to any rumours about a deposition.

While Julius grappled with his enemies, Raphael and his pupils continued to decorate the papal apartments. As the work progressed, figures became larger and looser. He had learned much from Michelangelo and Leonardo and he brought his figures to life with more determined brush strokes. His pupils had learned to imitate Raphael's style so perfectly that it was difficult to tell the hand of the master from that of his school. This left Raphael more time to search for new clients, and, as Vasari asserts, to dedicate himself to amorous adventures.

Meanwhile the pope requested a canvas for the church of San Sisto in Piacenza, in honour of his uncle, Sixtus IV. The family had a long association with the church. Julius asked for a Madonna holding the infant Christ flanked by the third-century Pope St Sixtus II and St Barbara of Lebanon, to whom Julius had a strong devotion. As the Virgin, holding the infant Christ, steps from behind green curtains on a bank of clouds, Pope St Sixtus, depicted with Julius's worn features, kneels in veneration.

Raphael chose canvas for the painting. It was a medium with which he was growing increasingly familiar. The hemp or cotton material was covered with gesso on which the oils were applied. Canvas had several advantages over wood. It could be easily rolled and transported. The drying time was shorter than that needed for oil on panel. The colours also reacted in a subtle way as glazes were applied over the dry pigments.

Agostino Chigi

The Papal States had a number of sources of income. Tenants paid an annual tithe and property holders paid rent. Farmers and other producers were taxed according to the size of their landholdings. Holders of ecclesiastical offices were also obliged to pay into the papal coffers upon receipt of their honour. The many pilgrims to Rome were a particular source of income as they all made small offerings of a few coins at the popular shrines.

The papal treasury, kept in large chests in Castel Sant'Angelo, was not simply for the payment of artists, clergy and courtiers. The papacy was responsible for the running of hospices, orphanages, hospitals and schools, and none of these streams of income alone was sufficient to pay for the administration of either the papal territories or the Roman Curia. Like most states in Europe at the time, the papacy continued to run at a deficit and successive popes relied on the services of bankers. One of the great bankers to the papacy in the High Renaissance was the Chigi bank of Siena, led by Agostino Chigi.

The family had been in business for some generations, but Agostino Chigi, who moved to Rome in 1487, had a flair unmatched throughout Europe. Chigi was one of the chief lenders to Pope Alexander VI and, in return, he had been granted lucrative contracts for the extraction and transport of salt and alum, which had been discovered near Volterra in 1460. With the election of Julius II, Agostino Chigi's fortune expanded enormously. Agostino had partly

sponsored della Rovere's attempt to be elected pontiff in 1503 when Julius borrowed money to support his efforts to win control of the rebel provinces within the Papal States. He borrowed from Agostino on favourable terms, and in gratitude made him treasurer to the Apostolic Camera, the central administrative body of the Curia.

Chigi further increased his wealth by making his own private investments in the production of salt and alum mines in the Papal States. The former was of great importance in the preservation of food while the latter was essential for the dyeing and glass-making trades. When Alfonso d'Este of Ferarra incurred Julius's wrath in 1510, Chigi confiscated his salt and alum mines. A jovial and shrewd man, Chigi matched Julius's patronage of the arts on a domestic scale, commissioning several artists to decorate his residences. As Raphael began to make his mark, Chigi took note. The financier wanted the young man to work for him, but to lure him from the pope's service was not advisable.

By 10 November 1510, Chigi had made an agreement with Raphael for the production of two bronze tondi. While he was a brilliant draftsman, Raphael had never yet cast in bronze and no documentation survives as to whether the commission was executed. The following year he was engaged to decorate the Chigi funerary chapel at the church of Santa Maria della Pace close to Piazza Navona.

It was through Chigi's patronage that Raphael was able to pry himself loose from religious paintings. In 1512 he returned to fresco and painted the *Triumph of Galatea*, based on Ovid's *Metamorphosis*, for Chigi's country residence. The influence of Michelangelo is clearly visible in the muscular nudes drawn with masterly foreshortening.

When Raphael arrived at the Chigi villa, he found Venetian artist Sebastiano del Piombo already at work. It was the beginning of a professional rivalry, more intense on Sebastiano's part. Raphael painted an elaborate ceiling featuring Chigi's horoscope in the loggia facing the garden.

The Death of Julius II

In early January 1513 rumours began to circulate about Julius's failing health The fifth session of the Lateran Council was under way but Julius failed to appear at the mid-February sitting. Speculation gathered pace and within a week the prognosis was confirmed. The pope spoke with his master of ceremonies, Paride de Grassi, of his impending death, clearly affected by 'having seen many popes who, once dead were immediately abandoned by their relatives and servants and neglected, with their private parts exposed'. In mid-February Julius summoned the cardinals to bid them farewell, urging them to oppose a French candidate and preserve the Papal States. Soon the whole court knew that Julius's condiction was critical. The Mantuan ambassador wrote to Isabella d'Este that Raphael was too upset to paint. On 21 February, after several weeks of intermittent fever, Pope Julius II died in his bedchamber.

The scenes following Julius's demise were extraordinary. For all his bluster, the Romans had respected him and had believed that he had their interests at heart. Ambassadors reported to their courts about the enormous crowds that queued for hours simply to pay their respects and touch the feet of the deceased pontiff. Among those who genuinely mourned Julius was Raphael, who owed this vital chapter in his career to his patronage.

However, not all were saddened to see the end of the pontificate. The Dutch scholar Erasmus wrote a satire on Julius's death the following year. As St Peter met the pontiff at the gates of heaven, he inquired why Julius thought he should enter. 'By my triple crown I swear that by my most magnificent triumphs, you, even you will feel the wrath of Julius,' replied the pontiff.

To this St Peter replied, 'You are mad, for till now all I hear about is a leader not of the Church but of the world. You boast about destroying alliances, starting wars, slaughtering people. That is the work of Satan, not of the pope.'

Chapter 8
Later Years in Rome (1513–17) – Leo X, the de' Medici Pope

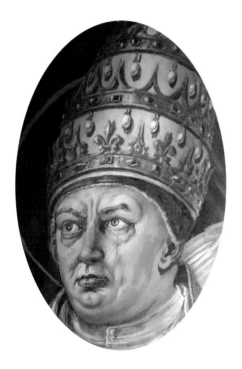

n 11 March 1513, Giovanni de' Medici, son of Lorenzo the Magnificent, called out the results of the ballots of his fellow cardinals assembled in the Sistine Chapel. To his surprise and delight, he declared that he had attained the majority of the votes and was duly elected pope. He announced that he would be known as Leo X.

Giovanni had almost missed the conclave to elect the successor to Pope Julius. When the news of the pope's demise reached him he was in Florence, suffering from abscesses for which doctors had failed to effect a cure. To his chagrin, he was carried into the conclave on a sedan chair, a humiliating posture for the thirty-seven-year-old cardinal. While the cardinals voted, the Florentine's excruciating fistula was being operated on by his doctors.

The conclave had opened on 4 March and the twenty-five cardinals present discussed the forthcoming ballots. It was an informal period when each faction could make its candidate known. Among the contenders were Raffaele Riario, nephew of the deceased pontiff, and Alessandro Farnese, the cardinal deacon of Sant' Eustacchio. The main contenders and their supporters were unable to agree terms and de' Medici was a compromise after just two days' voting.

The cardinals in conclave were weary of Julius's continuous badgering and belligerence. They wanted a more docile pope, one who would leave them to their own devices, free to govern the Church. The cardinals trusted that Giovanni would have no appetite for interminable wars to secure the Papal States but would content himself with embellishing the Vatican.

The bells tolled and the crowd gathered in St Peter's Square, still a construction site and covered with scaffolding. Within a few hours news of the election reached Florence. The de' Medici had returned to power a year earlier and there was a veritable explosion of excitement as their supporters filled the taverns and public squares. The hills around Florence burned brightly as bonfires were lit to celebrate the return of the de' Medici and the accession of the first de' Medici pope. Giovanni de' Medici was a deacon and was ordained a priest two days after his election and then a bishop before his coronation took place on 19 March.

All members of the papal court had waited anxiously for the results of the conclave, for the emergence of a victor could spell either disaster or further preferment. From the most elderly cardinal to the youngest page, most hoped that Leo would not espouse the military exploits of his predecessor. Leo made it clear upon his election that his would be a golden era of peace and increased prosperity. Raphael greeted the news of his election with a mixture of relief and elation – the new pope had long been recognised as a generous patron of the arts.

The first sign of the pope's spendthrift generosity came with his coronation on 11 April, aptly scheduled for the feast of Pope St Leo the Great. The cavalcade crossed the Tiber and wound its way through the heart of the old city, skirting the Forum before ascending the Caelian hill to the ancient residence of the popes. A colourful band preceded the procession of cardinals, bishops, princes and clergy, as timpanists beat time for the papal march. The pope was so heavy that he had to ride side-sadle on his white Arab stallion. Swathed in silk and satin vestments with a heavy gold tiara on his head, the pope sweated profusely in the warm spring sunshine. All the leading artists had designed makeshift triumphal arches, erected outside the *palazzi* of the Roman nobility. The cost of the coronation for the son of Lorenzo the Magnificent was in excess of 150,000 ducats, one seventh of the papal treasury.

Giovanni de' Medici

Giovanni de' Medici and his cousin Giulio had been marked out for ecclesiastical careers since their youth. While still a child, Giovanni was given a number of ecclesiastical benefices by Pope Innocent VIII, whose illegitimate son was married to Maddalena, daughter of Lorenzo the Magnificent. When he was eleven, the boy was made commendatory abbot of Montecassino and two years later was appointed commendatory abbot of Morimondo near Milan. By the time he was created cardinal on 9 March 1489, Giovanni possessed thirty benefices which brought him substantial wealth.

Innocent elevated Giovanni to the Sacred College of Cardinals on the condition that the nomination would remain secret for three years. On that occasion, Lorenzo had written to his young son, 'Silk and jewels are not suitable for a person of your rank. Acquire a few remains of antiquity and a collection of beautiful books.'

While the cardinal had ignored his father's advice about clothing and jewellery, he had avidly collected antiquities and books.

On the death of his father in April 1492, the sixteen-year-old Giovanni was appointed pontifical legate to Florence, in order to assist the succession of his brother Piero. Within a few weeks the Florentines had thrown off de' Medici rule and exiled the family. Giovanni and Giulio left Italy for northern Europe where they lived for a number of years. With the death of Piero in 1503, Giovanni became the head of the family. In that same year, with the accession of Pope Julius II, the cousins' fortunes changed. Giovanni moved to Rome and took up residence at the Palazzo Madama. On 1 October 1511, Julius named him papal superintendent to Bologna, placing him in charge of the troops of the Holy League against the French. The coalition of troops was vastly outnumbered and, during the

Battle of Ravenna on 11 April 1512, Giovanni was captured by the French. Escaping his captors, the cardinal managed to rejoin the delegates of the Holy League. Exorbitant bribery helped him to raise troops to restore the family to rule in Florence. The troops attacked the nearby town of Prato on 29 August 1512, with the slaughter of thousands who had taken refuge within the walls. The shameful savagery of the soldiers convinced the Florentines to surrender to the de' Medici forces rather than risk further bloodshed.

Although he was corpulent and suffered from severe gout, Leo may have reasonably looked forward to many happy years as pontiff. He expected to enjoy whatever works he would undertake to glorify the Church and bring lustre to the house of de' Medici. A month following his election, Leo created his cousin Giulio a cardinal and archbishop of Florence, thus cementing de' Medici control of the city.

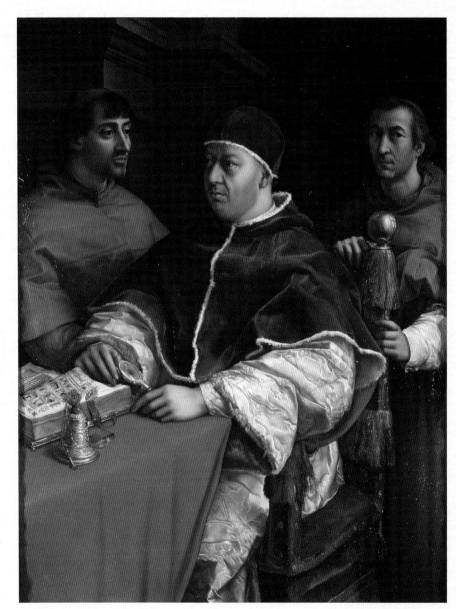

Family portrait painted by Raphael in 1518 of Pope Leo X with Cardinal Luigi de Rossi and his cousin, Giulio de' Medici

Following a four-hour coronation ceremony, the pope provided refreshments for the participants in the gardens of the old Lateran palace, which had been cleaned up for the occasion. The aristocracy and members of the Curia managed to push their way into the shabby Lateran palace where trestle tables were laden with food and beverages. The dinner for the new pope and his family and select members of the papal court consisted of sixty-five courses. A young boy seated at the pope's table was painted head to toe with gold leaf, indicating the dawn of a new golden age. For ordinary Romans, after the pontifical blessing *urbi et orbi* from the loggia, the celebrations were just beginning. Wine kegs and delicacies were on offer to help commemorate the auspicious occasion.

Until mid-summer, Leo attended a series of lavish meals and parties to celebrate the beginning of his pontificate. Commencing in the late afternoons, they rarely ended before the early hours of the morning, when the pope returned to his residence, laden with gifts from grateful recipients of pontifical favours.

Among the coronation presents was an exotic gift from the king of Portugal, Manuel I, who had shipped an elephant from Lisbon to Rome. Previous Portuguese kings had sent Leo's predecessors monkeys, parrots, mandrills, tigers and leopards, but none had pleased a pope like Annone, the white elephant. The pope housed the elephant in Bramante's newly built Belvedere courtyard and allowed the people to visit the stable each weekend. The animal also took part in religious processions, which drew large crowds of curious Romans and astonished pilgrims. Leo commissioned Raphael to paint a fresco of the white elephant at the entrance to the Vatican. Raphael made a number of sketches of the elphant which featured in papal processions and entertainments. The fresco remained over the entrance to the Vatican until the seventeenth century, when it was removed to make way for Bernini's great colonnade.

Drawing by Raphael of
Annone, the white elephant

Raphael's First Commission from Leo X

When Leo was elected Raphael had just completed the second stanza of the papal apartments, *The Expulsion of Helidorus from the Temple*, which he had commenced in 1511. He waited to see if Leo would hire him to paint the adjacent room.

Giovanni de' Medici was a contemporary of Michelangelo, and the pope's father had invited the young artist to study at his home. However, Giovanni and Michelangelo had little in common. The future pope found the surly

sculptor to be both moody and melancholic. Described by his contemporaries as amiable and affable, Leo was drawn to the mild-mannered and graceful Raphael, whose charm and cheerfulness were in tune with the pontiff's optimistic outlook on life.

In 1514, Leo entrusted Raphael with the decoration of his dining room, which had been used by Julius as the highest court of the Holy See. The ceiling had been decorated by Perugino in 1508 with personifications of Justice and Charity. Raphael's commission was to decorate the lateral walls. He illustrated them with episodes from the biographies of three of Leo's precedessors who had his name, taken from the medieval *Liber Pontificalis*. The frescoing of the walls Raphael left to the talents of his school following his instructions.

The Coronation of Charlemagne recalled the visit of the Frankish king Charles the Great to Rome, where he was crowned Holy Roman Emperor by Pope Leo III on Christmas Day 800. The painting carried a political message – Pope Leo III bore the features of Leo X, while Charlemagne resembled King Francis I of France. The fresco, probably painted by Perino del Vaga, subtly reminded viewers that the de' Medici pope had signed a concordat with King Francis during his visit to Bologna in 1515, while the fresco was being painted.

According to the *Liber Pontificalis*, a fire broke out in the Borgo district in front of St Peter's Basilica in 847. As the citizens of Rome fled the flames, Pope Leo IV appeared in the loggia of the basilica to bless the people. At that point, the fire was miraculously extinguished. In this second fresco, the pope bears the features of Pope Leo X. The fresco may have been executed by Gianfrancesco Penni following Raphael's design.

The third scene, probably painted by Giulio Romano, represents the Battle of Ostia, when Pope Leo IV defended the city from the invasion of Saracens, intent on pillaging Rome. As in the earlier paintings, the earlier Leo bears the features of Pope Leo X, who intended to launch a crusade against the Muslims in Palestine.

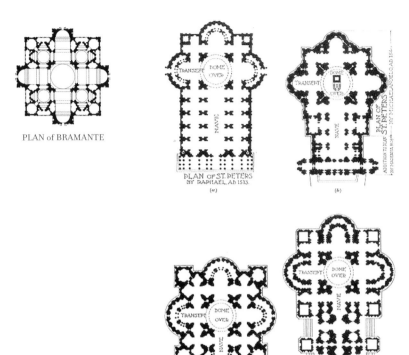

PLAN of BRAMANTE

PLAN of ST. PETERS BY RAPHAEL, A.D. 1513. (a)

PLAN OF ST. PETERS ADDITION TO PLAN BY MADERNA 1604 — BY MICHAELANGELO A.D. 1546 (b)

PLAN OF ST. PETERS BY PERUZZI A.D. 1520. (c)

PLAN of ST. PETERS BY SAN GALLO, A.D. 1550 (d)

The changing face of St Peter's Basilica: Bramante, Raphael, Michelangelo, Peruzzi, San Gallo

St Peter's Basilica

The death of Bramante on 11 March 1514 presented Leo with the opportunity of conferring a further honour upon Raphael. On 1 April, he appointed him architect of St Peter's Basilica. On the same day the celebrated architect Giuliano da Sangallo and the Veronese engineer Fra Giocondo were both appointed to assist Raphael with his design for the new basilica.

Raphael was exultant at his good fortune. On 1 July of that year, he wrote to his uncle, Simone Ciarla. Excusing the gap of some months since his last

letter, Raphael explained how he had succeeded Bramante as architect at St Peter's and had been commissioned by the pope to paint another room in the private apartments.

The post carried a handsome stipend which was augmented by payment for the innovations that Raphael introduced to the original plan. Bramante had left drawings for the new basilica, four chapels around a central cupola in the shape of a Greek cross. He had assembled a team, which had been at work for seven years, dismantling the old basilica and contructing a more workable building. The basilica was now a building site, and pilgrims were accompanied down a temporary wooden scaffold to pray at the tomb of St Peter. Raphael saw no need to change the Greek cross outline of the basilica. It called to mind the Pantheon, the best preserved of the temples of the ancient world.

While Raphael had no formal training as an architect and his principal skills were in drawing and painting, he understood enough to work with the team of architects and builders that Bramante had put in place.

In 1511, a Latin edition of Vitruvius' *De Architectura* was published in Venice by Giovanni da Tridentino. Raphael received a copy, complete with woodcut illustrations, a year or two later. As his Latin was rudimentary, he invited Fabio Calvo to live with him while he translated a fair copy into Italian. Although familiar with the basics of classical architecture and perspective, Raphael wrote enthusiastically about the Roman writer and the ancient techniques he described, many of which had changed little over one and a half millennia.

Raphael must have contemplated marriage at some point but the pace of life seemed to leave him little time for amorous pursuits. In a letter to Simone Ciarla that July he stated that he was wise not to have taken a wife in Urbino because Cardinal Bibbiena had proposed that he marry one of his relatives.

With regards a wife, I must tell you that I am grateful each day that I did not accept the one that you wanted for me, or indeed, any other. I have been wiser than you in this case. I have capital in Rome worth some

three thousand ducats and the assurance of fifty more. His Holiness
pays me 300 ducats for the rebuilding of St Peter's, an annual pension
for life. In addition, whatever I ask for they pay me. I have begun the
decoration of a large hall for which I expect twelve hundred gold crowns.
As you can see, I bring honour to my family and my homeland.

Raphael confidently assured his uncle that he knew what he was doing. 'I intend to find a maiden … who will give me a dowry of three thousand gold scudi, one who lives in Rome because a hundred ducats here are worth two hundred there. You may depend on it.'

Marriage in sixteenth-century Italy was an important means of preserving a healthy society. It provided suitable partners and united families in valuable alliances. Wives brought dowries, which enriched their husbands, but also ensured the financial stability of the new family unit. Brides were typically much younger than grooms. They were often betrothed as young teenagers to men twice their age in order to guarantee their virginity. The families of young women usually sought a suitable partner with healthy prospects. Widows reverted to their original family and, unless provided for by their deceased spouse, had to produce a second dowry if they hoped to remarry.

Raphael assured his uncle that he would marry Bibbiena's relative for it certainly seemed a very suitable match. But Raphael clearly had either not met the young woman in question, or barely knew her. What was important was that the marriage would bring him into the family of the influential cardinal, one of Leo's closest advisers, and of course, a candidate in any future conclave.

Raphael made no further mention of Bibbiena's suggestion of marriage. At the time of his death he was unmarried, although a certain Maria Bibbiena, presumed to have been his fiancée, predeceased him and was buried close to the tomb that he had chosen as his burial place.

In his *Lives of the Illustrious, Painters, Sculptors and Architects*, Vasari reported a rumour that might have explained why the handsome young man remained

a bachelor. According to Vasari, Raphael believed that Pope Leo intended creating him a cardinal. There was no obligation on cardinals to be clerics, although they were normally deacons, bound by a vow of celibacy. As successive popes and numerous cardinals of recent years had proved, the vow was meaningless – pontiffs and clerics regularly had children born to mistresses. Yet, while cardinals conducted illicit affairs, none were actually married.

A Flourishing Career

At the age of thirty-two, Raphael had reached the height of his creative powers and was a popular figure both at the papal court and among the aristocracy and upper classes of the city. In 1515 he painted an oil portrait of Bindo Altoviti, the son of Antonio Altoviti, Master of the Papal Mint.

The commission to paint the twenty-four-year-old Bindo, grand-nephew of Pope Innocent VIII, further ehanced Raphael's reputation as a portrait painter. The youth was much admired for his blond hair and vivid green eyes. Raphael set the young financier, robed in an expensive blue mantle, against a green background. Altoviti turns and looks over his shoulder at the viewer. With a delicacy hitherto unknown in portrait painting, Raphael reveals some stray hairs as Altoviti's locks fall to his shoulders.

All Raphael's portrait sitters show themselves to be relaxed in his presence, underscoring the commentaries of most of his contemporaries who repeatedly describe his 'sweetness and sincerity'. This charm explains how Raphael was able to gather a loyal *bottega* around him and to attract patrons who vied with one another to have their portraits painted.

In the autumn of 1512, on completion of the Sistine ceiling, Michelangelo had left the Vatican and returned to his family in Florence. From the early autumn of 1514 until 1516, while Raphael's career was flourishing, Leonardo da Vinci lived at the Belevedere Court at the Vatican, receiving a monthly allowance of thirty-five ducats from the pope, but no artistic commission. Vasari

noted that Leonardo made small wax animals that he endeavoured to make fly. When shown an unusual lizard by the gardener, he made wings from lizard scales and added eyes, horns and a beard. Vasari adds, unsurprisingly, that when Leonardo showed the strange animal to people, they fled in fright.

Raphael's reputation and financial situation continued to improve. On 27 August 1515, Leo wrote to him with regard to the amount of stone needed for St Peter's. Acknowledging that the city had a vast number of ruins the pope wrote, 'I appoint you as superintendent of all the marbles and stones which shall be dug up in Rome, or within ten miles of Rome, so that you might purchase for me what is suitable for the building of that temple.' Leo was aware that for centuries Romans had heedlessly used ancient marble to build walls and smaller edifices. He knew that many such stones contained important inscriptions and he imposed a fine on anyone who did not obtain Raphael's permission to reuse the material.

In fact, as his team of painters worked at the Vatican, Raphael had already begun to explore the ruins of ancient Rome with the intention of making a visual record of the remains. The increase in the size of printing presses made the production of larger books possible, and Raphael contemplated making etchings of some of the great monuments that had survived from antiquity.

For more than a thousand years the monuments had stood, silently decaying through neglect or plundered to provide building materials. Many poor families had constructed makeshift houses in the arches of the Colosseum while the wealthier citizens built fortified residences on the broken

Johannes Gutenberg,
inventor of the printing press

roof of the Theatre of Marcellus, built fifteen centuries earlier by the emperor Augustus. Many monuments lay half-buried under centuries of silt and rubble.

Raphael had deplored the destruction of ancient Rome and appealed to Leo to prevent the further decline of the city. He found two broken Egyptian obelisks close to the ruins of the mausoleum of Augustus near the banks of the Tiber, one of which he proposed to erect in St Peter's Square. A letter from Marco Minio to the Venetian senate lamented that the first emperor's tomb was little more than a lime-kiln. To add to the insult, the lilm-kiln belonged to a member of the Riario della Rovere family, notorious for their extravagance.

The uncovering of ancient Rome continued in the opening years of the sixteenth century. For a few coins, visitors were allowed explore the Nero's *Domus Aurea*. Raphael and Michelangelo were among the curious visitors who were lowered by rope into the hollows to examine the walls, which had been painted more than fourteen centuries earlier. In the flickering light of hemp torches, artists sketched the nymphs and cupids that adorned the walls.

Writing at this time, the Florentine diplomat and writer, Niccolò Macchievelli, explained the pleasure he derived from his study of classical antiquity. Each evening he spent several hours absorbed in his library. 'At the door, I take off my muddy everyday clothes. I dress myself as if I were about to appear as the envoy of Florence at a royal court. Then, suitably attired, I enter the courts of the men of antiquity. They receive me with great friendship. From them I receive the nourishment which is mine and for which I was born. For four long and happy hours I forget all my troubles. I am not afraid of poverty or death and I transform utterly in their likeness.'

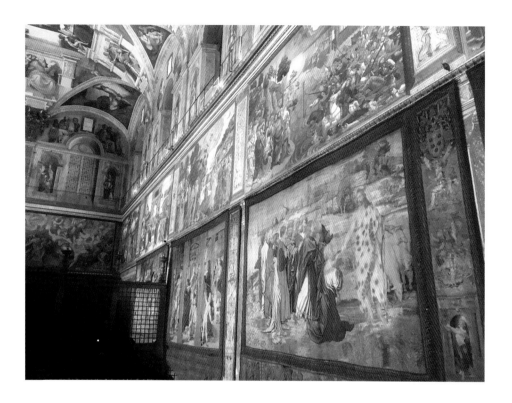

Tapestries for the Sistine Chapel

As Raphael entered the Sistine Chapel from the Sala Regia in the early spring of 1515, he examined the structure and its decoration with a new eye. He had just received an order from Pope Leo to design a set of sixteen tapestries to hang on the lower walls. The proposal had come during one of his daily meetings with the pope.

Curtains had been used since antiquity to provide shelter from draughts, or to close one section from another within large buildings and churches. Over the centuries, tapestries had replaced the embroidered curtains, and skilled weavers produced sumptuous works of art to grace the walls of churches,

Detail from tapestry showing the martyrdom of St Stephen

cloisters, castles and chapels. The medieval period was the high point of the production of the colourful decorations. The workshops of France and Flanders produced the most elegant designs, often depicting the chase, scenes of courtly love or images from the field of battle.

Raphael had first seen tapestries as a boy when he accompanied his father to the palace of Urbino. Federico had collected a large number of wall tapestries from French and Flemish looms. They were the most luxurious and expensive form of decoration, far more costly than fresco. They were woven with expensive silk threads in a variety of hues and, occasionally, gold or silver thread.

During the decoration of the Sistine Chapel by Tuscan artists in the latter half of the fifteenth century, twelve fictive curtains were painted on the lower register of the walls. The frescos imitated silk curtains, interwoven with images of the oak tree, the heraldic symbol of the della Rovere family. The folds were gathered at regular intervals, beneath a faint depiction of the papal tiara and keys. The name of Sixtus IV seemed woven into the fabric. The two contracts for the work, dated 27 October 1481 and 17 January 1482, had stipulated that each artist was responsible for the main fresco, the painted frame, the images of the popes above and the painted curtain below. The artists approached the work with their own style, and each curtain was slightly different. At first glance, the imitation drapes look so real that the eye is swept upwards to admire the cycle of the lives of Moses and Christ above.

Raphael examined the painted curtains carefully. The pope had commissioned him to depict scenes from the lives of St

Peter and St Paul, the patron saints of Rome. The tapestries were based on episodes from the Acts of the Apostles in the New Testament. Raphael chose eight episodes and miracles from the life of St Peter, traditionally regarded as the first pope. A further eight panels recounted events and miracles from the life of St Paul, the first great teacher and missionary of the Christian faith. In the lower band of each tapestry, beneath the main frame, Raphael was to depict scenes from Leo's pontificate. Leo intended the tapestries to reflect the prestige of his pontificate, which based itself on the authority of St Peter. Heedless of the cost, he demanded the most elegant work that money could buy.

By contrast with Michelangelo's great creation cycle completed just three years earlier, the frescos painted by Pietro Perugino, Sandro Botticelli, Cosimo Rosselli and Domenico Ghirlandaio for Pope Sixtus IV appeared dated. Raphael could see how Michelangelo's technique and use of nudes had propelled the art form onwards, making the earlier works appear colourful but cramped by comparison. Raphael was acutely aware that Michelangelo would watch his progress closely and he wanted to match, if not surpass, the Florentine's great ceiling.

As he considered the fresco cycle, Raphael decided to follow the style developed by Michelangelo, whose large muscular figures covered the ceiling. His immediate challenge was to work out the proportions so that his figures blended with the frescos of the Tuscan artists painted over three decades earlier in a style that had been abandoned by contemporary artists.

Detail from tapestry showing St Peter meeting Christ

Raphael knew that there was no weaver in Italy capable of producing the large tapestries within a reasonable time. Leo chose the workshop of Pieter van Aelst in Flanders, which he had visited years earlier, to execute his designs. Raphael ordered large sheets of paper from Bologna and glued them into enormous rectangles so that he could draw the cartoons for the tapestries. He took charge of the entire enterprise himself, not wishing to delegate a thread to an understudy. He drew the outline, and indicated with a dab of paint the colour that his painters would continue. He painted the faces himself. The tapestries cost 1,500 ducats each, and the artist received 100 ducats per tapestry. Raphael dispatched the rolled cartoons to Brussels in the early summer of 1516, appointing an agent to liaise with him in Rome.

The Flemish weavers were regarded as the finest in Europe. The tapestries had to be woven in reverse from the cartoons. Each large cartoon was cut into five segments so that all the looms could work at the same time. When finished, the five segments were stitched together and bound with an embroidered border.

At the same time, Raphael made an agreement with Marcantonio Raimondi and Agostino Veneziano to make engravings of three of the designs, *The Preaching of St Paul*, *The Stoning of St Stephen* and *The Conversion of the Proconsul*. The engravings spread Raphael's fame throughout northern Europe. He had discussions with Raimundi to engrave designs for a book commemorating the monuments of ancient Rome, but the project came to nothing.

Pope Leo Consolidates his Rule

On 8 November 1515, Raphael entered into a contract to purchase a new house on Via Sistina in the Borgo, a sign of his increasing wealth and social status. His relationship with the pope was firmly established and Leo, for his part, appreciated Raphael's charm and talent. Unlike Julius, Leo read Greek and

Latin and conversed fluently in the latter. He also composed music and took a keen interest in the decorative programme of both the Vatican and the city. To further the humanistic study of the classics, Leo established a chair of Greek at La Sapenzia University and set up a printing press.

Pope Leo was as opposed to the presence of barbarians on Italian soil as had been his predecessor. However, rather than wage expensive military campaigns, he intended to unify Ferrara, Urbino, Parma, Modena and Piacenza under Florentine rule on behalf of the papacy. With the help of the Duke of Milan, he intended to extend Florentine rule as far south as Naples in order to protect the lands held by the Church. The plan would be carried out by his brother Giuliano, *gonfaloniere* of the Holy Roman Church

Leo's intentions were thwarted by the acccession to the French throne of Francis I, who had succeeded Louis XII in January 1515. Francis dreamed of resurrecting Charles VIII's plan to take Naples for the French crown. Leo hastily convened an alliance with the Spanish, the Swiss and the Holy Roman Emperor. The troops were no match for the French, who won a number of brief skirmishes in northern Italy. Unable to raise the funds for battle, Leo requested a mediation with Francis in Bologna.

At the end of November 1515, the pope made a grand entrance into his native city. The Florentines gave him a rapturous welcome. His role in the slaughter of the Prato rebels was forgiven by the citizens, who rejoiced in him as the first Florentine pope. Travelling on to Bologna, the goal of his visit, Leo met Francis, who demanded the surrender of various cities within the Papal States. While Leo publicly protested that

The printing press

he could not give Church property to France, he secretly negotiated a concordat in the hope of bringing peace to Italy.

The death of King Ferdinand of Spain on 26 January 1516 required the pope's return to Rome. Francis had been appeased and had left Italy for France. On his way to Rome, Leo paused in Florence to visit his dying brother, Giuliano. Leo told Giuliano of his plan to depose Francesco Maria della Rovere as Duke of Urbino and install their twenty-four-year-old nephew, Lorenzo de' Medici, in his place. The dying man urged his brother not to impose the de' Medici on Urbino.

Shortly after his arrival in Rome on 28 February, Leo summoned the Duke of Urbino to explain why he had not assisted the pope in his negotiations with King Francis. Leo also accused him of participating in the assassination of his dear friend Cardinal Alidosi four years earlier in Ravenna. Suspecting that Leo wished to use this as an excuse to oust him from Urbino, the duke fled to Mantua, whereupon Leo appointed Lorenzo de' Medici as duke in his stead. Gathering mercenaries, della Rovere launched a series of expensive battles against the new duke. Lorenzo was wounded and was forced to return to Florence. Leo asserted that the expenditure of money on mercenaries had brought peace to central Italy. In reality it simply consolidated de' Medici control at the heart of the Papal States.

In the summer of 1516, Annone, the pope's elephant, became ill. Leo despatched his personal physician to attend to the animal. With little knowledge of veterinary practices, the doctor administered suppositories of gold. The animal grew weaker and died on 8 June, a tearful Leo at his side. The pope ordered the animal to be buried in the Belvedere courtyard and commissioned Raphael to paint a fresco depicting his pet above the tomb.

In June of that same year Raphael signed a new contract for the altarpiece for the long-suffering nuns in Monteluce, with whom he had first signed a contract and received an advance in 1503, promising his immediate atten-

Belvedere Courtyard

tion. As the Poor Clares were an enclosed order, they had to rely on their agent to put pressure on Raphael. The agent failed in his task and no further progress was made on the canvas.

In the winter of 1516 Raphael received a prestigious commission from Cardinal Giulio de' Medici, Pope Leo's cousin and closest adviser. The cardinal, the absentee archbishop of Narbonne, asked Raphael to paint a transfiguration of Christ for the French cathedral. He also commissioned a second altarpiece, *The Resurrection of Lazarus*, from Sebastiano de Piombo, in the knowledge that the double commission would lead to rivalry between the two artists.

A Plot to Assassinate the Pope

In the spring of 1517, as the last session of the Fifth Lateran Council was coming to an end, news circulated at the papal court of a plot to poison the pope. To Leo's dismay, the would-be assassins included a number of his trusted cardinals who had schemed against the de' Medici pope for the preferment of their families. Chief among them was twenty-six-year-old Alfonso Petrucci of Siena. Among the other plotters were Cardinals Soderini of Florence, Castellesi of Corneto, Sauli of Genoa and Riario of Rome, all of whom had assisted Petrucci in defending Siena from the miltary advances of Florence. According to the pope's informants, trustworthy or not, Petrucci had bribed Leo's doctor, Battista di Vercelli, to administer a poisoned ointment in the treatment of abscesses. Leo summoned the suspects, one by one, to Rome, pretending that they were to attend an ordinary consistory. In a matter of days, the cardinals were arrested and confined to the papal fortress at Castel Sant'Angelo where they confessed to their role in the plot.

Leo deprived the guilty cardinals of money and properties, exiling all but Petrucci, who was imprisoned in the dungeon at Castel Sant'Angelo. The papal doctor and Petrucci's secretary were executed on 27 June and their corpses dragged through the streets of Rome as a warning to other would-be assassins. In mid-July Cardinal Petrucci was strangled. In deference to his cardinalatial dignity, the executioner was a Muslim.

The pope, who had extracted hundreds of thousands of ducats from the repentant cardinals, took the opportunity on 1 July to create thirty-one new cardinals. New members of the Sacred College of Cardinals traditionally paid a sum to the pope who admitted them. When the tally of offerings was made, Leo had made a profit of over half a million gold ducats, destined to pay off some of his considerable debts and allow him to continue to shower his generosity on those artists whose work he so greatly valued. However, despite the contributions of the new cardinals, Leo's final and total financial collapse was only months away.

hile the Flemish weavers were embroidering their cloth with the richest dyed silk threads in the execution of Raphael's designs for the Sistine tapestries, a friar in northern Germany was preparing to unravel the fabric of Christendom.

Martin Luther: The Winds of Reform

In 1517, a German university lecturer and friar of the order of St Augustine prepared a list of abuses in the Church. His collection of ninety-five complaints was not new. Various reformers had pointed out the need for renewal and the eradication of scandalous abuses within the Church. The root causes were myriad, and no single voice of protest had ever enumerated the issues that needed to be addressed. Money and the sacred scriptures lay at the heart of the Church's problems. Simony, the buying and selling of ecclesiastical offices, had been a source of scandal for centuries. Clerics bought positions that generated considerable incomes without any obligations, or obligations that they blithely ignored. It was not rare for such clerics to gather a number of offices from which they could derive a comfortable, if not luxurious lifestyle. While Christ had condemned the rich and lauded the poor, priests, bishops, cardinals and popes regularly spent money destined for the support of a local Christian community on themselves, and on bribing others in order to gain further assistance in their corruption.

Within two years of Leo X's election, the papal treasury carefully replenished by Julius II was all but empty. An anonymous lampoonist ridiculed his vanity: 'He consumed three pontificates, eating up the treasure of Julius II, the

revenues of his own reign and those of his successor.' But Leo's career was not unusual – for centuries ecclesiastical positions had been hawked for money and favours.

To pay for the new St Peter's Basilica, Leo authorised his ecclesiastical agents in Germany and Denmark to redouble their efforts to gain money from the sale of indulgences. Leo was not the first pope to sell indulgences. The small monetary offering made by the penitent was presented as a sacrifice on behalf of the souls in Purgatory. Some theologians taught that the life and death of Christ and the saints had built up a spiritual treasury from which people could merit. The aim was to free the souls of the deceased from Purgatory.

Purgatory is not mentioned in the Bible but some medieval theologians argued that souls could be purified, or purged of sin after death. The concept of reducing the time of temporal punishment and expurgation was disputed by many theologians, who argued that the prayers of the living could not assist those who had died. While the concept of penance and reparation had been part of Church teaching from the Apostolic Era, the theory that people could be forgiven after death developed slowly. By the Middle Ages, remission from penance could be obtained by charitable works, prayers, pilgrimages, crusades and almsgiving. By the ninth century, it was common for people to undertake pilgrimages to the shrines of the saints for the remission of sins, and some paid proxies to make the journey in their stead.

It was against this backdrop that Martin Luther challenged the Church authorities to a debate on the roots of abuse. The university was an appropriate setting for such an academic discussion, as competent theologians could contribute to the arguments and formulate a solution. But the scorching questions were directed not so much against doctrine but against Leo's abuses. Luther had visited Rome seven years earlier, and had witnessed the excesses of the papal court and had heard rumours of the scandalous behaviour of Pope

Julius. Raphael had painted Julius's illegitimate daughter, Felice della Rovere, in his fresco in the papal apartments, *The Mass of Bolsena*. Under Leo, Luther asserted, the situation had further deteriorated.

In the eighty-third thesis, Luther asked, 'Why does the pope, whose wealth today is greater than the wealth of the richest Crassus, build the basilica of St Peter with the money of poor believers rather than with his own money?'

Leo's financial outlay was not limited to the vast project of the rebuilding of St Peter's. Wars against the French presence on Italian soil, rebellions in the Papal States and the desire to call a crusade against the westward advance of the Turks all required enormous funds. In the imminent election for the

Friar Johann Tetzel Selling Indulgences, painted by Franz Wagner

successor to the imperial throne Leo was working to oppose the candidature of the Spanish Charles V as well as the pretensions of Francis I of France.

There had been other calls for reform. In England, in the fourteenth century, John Wycliff had denounced the corruption of his fellow clergy and had translated the Bible from Latin into English, arguing that 'even a ploughboy should hear and understand the Word of God in his own language'. At the beginning of the fifteenth century, the Bohemian priest John Hus exposed the hypocrisy of many of his contemporaries and objected to the sale of indulgences. In 1415, he was summoned to the Council of Pisa where he was condemned as a heretic and burned at the stake.

Had Luther's challenge remained within the walls of the university, it would have been no more remarkable than any other academic debate. But the Latin theses were translated into German and printed as pamphlets. Thousands of paper leaflets were distributed widely across Germany, making the friar a familiar household name. To his surprise, Luther was supported by several princes, who, either for political oportunism or out of genuine piety, offered him protection from ecclesiastical discipline.

Luther's challenge reached Rome in January 1518. Leo did not examine his objections in particular detail and, although highly cultured, he may not have understood the theological intricacies of the friar's argument. When Luther sobered up, Leo quipped, he would come to his senses. The pope was, however, aware of the political turmoil that the debate had engendered. On 3 February 1518, he wrote to the vicar general of the Augustinian hermits, instructing him to silence the rebel academic. The injunction proved fruitless and Leo initiated a judicial process three months later. When Luther had failed to respond, in June 1520 the pope issued a papal bull entitled *Exsurge Domine* (Arise, O Lord) threatening to excommunicate the friar unless he recanted his propositions within sixty days. Luther did not recant, so in January 1521, Pope Leo X excommunicated him.

Leo claimed, somewhat vaguely, that his pontificate had the sole aim of defending the Church from her enemies. He hoped to expand Christianity across the newly discovered territories of Spain and Portugal and intended that Francis, if he became emperor, would support a campaign to drive the Turks from Europe. He was publicaly hailed by Girolamo Benivieni, a follower of Savonarola, as the scriptural 'Lion of Judah' who would lead the Church into the Apocalypse.

Leo's world view was restricted by the walls of ancient Rome. The ephemeral beauties of the city engaged him more than the Teutonic debates. He had never paid attention to his critics. Erasmus had derided his papacy as 'a pestilence to Christianity', while Machiavelli had condemned the papal court as 'having destroyed all piety and religion in Italy'. However, those judgements were balanced by the Venetian ambassadors, who noted his genuine piety. Leo's contemporary, Paolo Giovio, noted that 'there has never been one of the previous popes who celebrated the Offices or with greater honour and respect offered the Sacred Sacrifice [of the Mass] than Pope Leo'. In this regard, Leo attentively followed and promulgated the reforming proposals of the Fifth Lateran Council, which he brought to a close in 1517. However, the publication of the reforming statutes did not lead to the eradication of centuries of abuse.

Martin Luther in his study

Keeping up with Demand

Raphael was too busy to take notice of the theological squabbles in Germany, even though they indirectly threatened his role as architect of St Peter's Basilica. By late 1517 he had undertaken the decoration of three external balconies for the

Raphael's Loggia in the Vatican

pope at the Apostolic Palace, which Bramante had designed shortly before his death in 1514. Raphael undertook to finish the project, dividing each of the long corridors into thirteen bays intersected with arches. He assigned the decoration and painting of the frescos to Giulio Romano and Giovanni da Udine. Da Udine had rediscovered the ancient art of stucco, lost for centuries, by studying the ancient ruins. Finished in 1519, the loggias gave an elevated view of the city of Rome. The walls, spandrels, lunettes, arches and pilasters were painted with human and animal figures inspired by the finds at Nero's *Domus Aurea* and other ruins that had been recently been excavated.

For all his success, Raphael was increasingly under pressure to supply his patrons. While his school decorated the loggia with myriad bright hues that caught the morning and afternoon sun, Raphael worked on four paintings commissioned by Pope Leo to be taken to France by Cardinal Bibbiena, the new papal legate.

The cardinal set off from Rome with the four panels carefully packed in wooden crates. *St Michael*, painted by Raphael and Giulio Romano, was a gift for the king, a member of the chivalric Order of St Michael the Archangel. *The Holy Family*, begun by Raphael and finished by Giulio Romano, was destined for Queen Clotilde, who had recently given birth to an heir.

As his reputation continued to spread beyond the Italian peninsula, Raphael gave three drawings to Raimondi to engrave: *The Preaching of Jesus at the Temple*, *The Slaughter of the Innocents* and *The Last Supper*. The designs were made specifically to spread knowledge of Raphael's artistic talent among

wealthy cognoscenti in northern Europe. No contracts survive to elucidate the arrangement Raphael had with Raimondi. Raphael may have received a small commission from the engraver, but, equally, Raimondi may have used the prints to gain more clients.

Although Raphael had few relatives, he was generous to his family in Urbino. On 7 June he met his maternal cousin, Fr Girolomo Vagnini, to whom he delegated his office as *scriptor brevium*. In addition to this financial assistance, he also arranged for his cousin to be appointed prior of the church of San Sergio, the chapel above the Santi property in Urbino. For their part, Raphael's relatives must have rejoiced in the success of their celebrated kinsman at the court of Pope Leo.

On 7 October 1517, Raphael signed a contract to purchase the Palazzo Caprini in the Borgo in front of St Peter's for 3,000 ducats. The Caprini family had commissioned the palace seven years earlier from Bramante. Raphael intended to live in the palazzo until he could build a new house on the Via Giulia, across the river.

He had recently finished decorating the pope's dining room where Leo entertained his closest collaborators beneath the brilliant frescos. Cardinal Bembo remarked that the room was always full of cardinals and merriment. As the visitors marvelled at Raphael's work, Leo spoke enthusiastically about his favourite painter.

In 1518, Agostino Chigi called Raphael back to his villa on the banks of the Tiber to decorate another chamber overlooking the garden with scenes from Greek mythology. The villa, designed by Baldassare Peruzzi a decade earlier, was Chigi's favorite residence. Raphael depicted the wedding of Cupid and Psyche, set in garlands of exotic fruit and flowers. According to Vasari, Raphael was distracted during the execution of the work by his love for an unidentified young girl. With great difficulty, Chigi persuaded the girl to move into the villa while Raphael worked on the frescos with Giulio Romano,

Gianfrancesco Penni and Giovanni da Udine. Vasari wrote that Raphael admired a number of women and was 'always ready to service them'.

On 30 April 1518, Leo and several of the younger cardinals whose company he enjoyed were entertained by Agostino Chigi in his magnificent villa. The pope was led through a corridor hung with silk curtains. Chigi may have entrusted the decoration of the salon to Raphael or some of his workmen who were then busy decorating the villa.

As the lunch progressed and the wine flowed prodigiously, the garrulous pontiff confided his plans to purchase land on which to construct a rural villa. Undoubtedly the two discussed the artist whose work they both so admired. As the meal was drawing to an end, Leo said that there was no room in the Vatican to rival the elegance of that in which they were dining.

Chigi clapped his hands and the tapestries and hangings fell to the ground. To the merriment of the guests, Chigi explained that the place in which they had dined was simply the stables over which the rich tapestries had been hung. The delighted pontiff took his leave, happy to have been the butt of an amusing practical joke. As the servants cleared the tables, they noted that several pieces of cutlery and silver plate were missing. The host ordered them to continue clearing and not to speak of the pilfering.

A further prestigious commission arrived in 1518 when Lorenzo II de' Medici was betrothed to Madeleine de la Tour d'Auvergne, cousin of King Francis I of France. In January of that year the bride had sent her portrait to her fiancé, whom she had not met. The duke reciprocated by sending his own portrait to his intended.

The half-length portrait was painted entirely by Raphael. He knew that the portrait of the duke in a gold velvet tunic and red and gold silk cloak would be seen by the king of France, who had recently brought the elderly Leonardo da Vinci to live close to his residence in Amboise in France. There was, therefore, hope of French royal patronage.

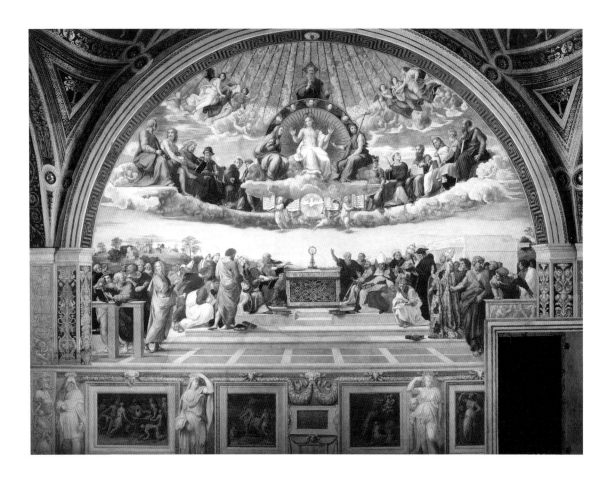

The marriage of Lorenzo and Madeleine was celebrated with pomp and ceremony on 13 June 1518, and on 8 September the ritual 'bedding of the bride' was enacted in Florence. The pope did not attend the Florentine celebration, but he had commissioned Raphael to paint his portrait for the occasion.

Raphael had initially intended to portray Leo alone, but he later added two of the pope's favourite cousins, the newly appointed vice-chancellor of

Disputation of the Holy Sacrament in the Stanza di Raffaello, Apostolic Palace

the Church, Giulio de' Medici, and the French-born Ludovico de Rossi, who had been made a cardinal on 1 July 1517, following the discovery of the Petrucci assassination plot.

Raphael placed Leo in the centre of the composition, seated on a throne. On a table covered with red drapery lay a bible or breviary, an elaborately ornamented bell and a magnifying glass. The pope, wearing a velvet mozzetta over a silk damask tunic lined with white fur, looks away from the viewer.

According to the pope's sister-in-law, Alfonsina Orsini de' Medici, the groom placed the portrait in the middle of the banqueting table beside the bride at the wedding feast. Lorenzo's mother said it was as if the pope was present for the celebrations.

Sebastiano di Piombo and Michelangelo enjoyed trading gossip, especially about other artists. In July 1518, di Piombo wrote to Michelangelo about the two commissions for Narbonne cathedral. According to him, Raphael had not even begun work. It was clear that not only had di Piombo himself started but that he was satisfied with his progress.

At the same time, the Duke of Mantua, ambassador to Alfonso I, made a similar report of Raphael's tardiness. He assured his master that Raphael would commence work shortly on *The Triumph of Bacchus* requested for the duke's 'Alabaster Room', diplomatically omitting to say that the artist was busy painting the loggia of the Apostolic Palace and working for Agostino Chigi. The duke had written some months earlier, complaining that Raphael was ill-mannered. Nobody should keep the duke waiting. He continued to needle Raphael, who sent a large cartoon of St Michael as a peace offering and promised a further painting, *The Hunt of Meleager,* as soon as he was able.

Although he employed over fifty workers in his *bottega*, Raphael was overworked and found difficulty in keeping up with the demands of his clients. The supervision of the numerous projects consumed most of his waking

hours, leaving him little time to paint. He had to pay bills, negotiate contracts, hire studio spaces and deal with demanding patrons. Two works in particular weighed on him. The Dei family regularly wrote to him demanding the conclusion of the altarpiece in the Florentine chapel in Santo Spirito that Raphael had abandoned in 1508. When Cardinal Bibbiena became papal legate in March 1518, he wanted to bring to France a painting of the vice-queen of Naples, Doña Isabella de Requesens. Raphael dispatched his *garzone*, Giuliano Romano, to draw the lady's features.

On 1 January 1519, Leonardo Sellaio wrote to Michelangelo in Florence, informing him that Sebastiano de Piombo had finished *The Raising of Lazarus*. Everybody, claimed Sellaio grandly, said that it was far superior to Raphael's effort. He maliciously added that de Piombo should not be afraid of anything – Chigi's newly painted vault had just been unveiled and it was judged even worse than Raphael's last room in the Apostolic Palace.

Meanwhile, Beltrame Costabili, the ambassador to Alfonso d'Este, wrote to his master that the portrait he had requested was delayed as Raphael was finishing *The Transfiguration* and claiming the pope was overworking him with a new project for a private villa and vineyard. Moreover, Raphael complained that the complex design for the Villa Madama for Cardinal de' Medici left him with little time for anything else. However, to keep the duke satisfied, Raphael offered to travel to meet him in Ferrara in the early summer.

Raphael had not been paid for his work on St Peter's Basilica since his appointment on 1 April 1514. Exactly five years later, on 1 April 1519, he received the sum of 1,500 ducats, 300 ducats per annum. It pales into insignificance when set against the 14,000 ducats paid by Pope Leo for the southern ambulatory alone.

A reminder of the fickleness of life and rule came with the news of the death of Lorenzo II, the Duke of Urbino, on 4 May 1519. The twenty-six-year-old duke had been wounded in the battle to retain the duchy and, three weeks

The Villa Farnesina

after the birth of his daughter, Catherine de' Medici, he had succumbed to gangrene. Pope Leo undertook the education of the infant, who, within half a century, would be the mother of three kings of France.

Following the death of Emperor Maximilian on 21 January 1519, the seven prince electors met to choose a new Holy Roman Emperor. There were three contenders, Francis I of France, Henry VIII of England and Charles V of Spain. Following six months of intrigue and bribery, Maximilian's grandson, Charles V, emerged victorious. In a letter to Pope Leo in July, the new emperor assured the pontiff that he would resolve the issue of the German friar, Martin Luther.

As the summer progressed, Pope Leo left the city to visit a number of cardinals at their country residences outside Rome. Despite the torrid heat, he returned for a special event held at the Villa Farnesina on 28 August. Agostino Chigi, by now a widower, had decided to marry his Venetian mistress of some eight years. It was an apt day, the feast of the fifth-century St Augustine of Hippo, whose mistress bore a son while Augustine was still in his teens.

There had been no children from Chigi's first marriage, but he had four with Francesca Ordeaschi. The pope bless-ed the marriage, legitimising the children. The guests would have been shown the latest artistic addition to the residence, the frescos in the bedchamber, painted by Il Sodoma, possibly based on a design by Raphael. The subject for the fresco was the marriage of Alexander the Great to the Bactrian princess Rox-anne. According to the poet Lucian, a painting of the subject had existed in imperial Rome.

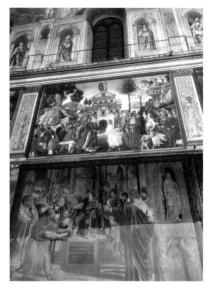

Details from tapestries

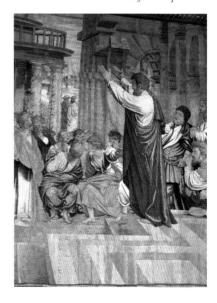

The Arrival of the Sistine Tapestries in the Vatican

Almost three years after Raphael had sent his painted cartoons to Flanders, seven of the tapestries arrived in Rome in the summer of 1519. Leo was so delighted with the enormous wall coverings that he ordered them to be hung on the feast of St Stephen, 26 December. The papal master of ceremonies, Paride de Grassi, noted in his diary the amazement of the papal court as they attended prayers with the pope. If the papal chapel at the Lateran had been described as 'no holier place in the world', then, de Grassi claimed, it could be said of the Sistine Chapel that 'now there is nothing in the world more beautiful'.

A few days later, on 29 December, Sebastiano di Piombo wrote to tell Michelangelo that his *Raising of Lazarus* had been displayed in the Apostolic Palace twenty days earlier. All, but for a few, had admitted it was beautiful. Di Piombo finished with a confident flourish: 'And I believe that my canvas is better designed than the bunch of tapestries which came from Flanders.'

Details from The Hall of Constantine: The Baptism of Constantine (above) *and grafitti on artwork. The Hall of Constantine was painted by Raphael's garzoni* after his death

Chapter 10
The Death of Raphael

n 6 April 1520, art historian Marcantonio Michiel noted in his diary that Raphael, who had always enjoyed good health, was seriously ill. He had been confined to home since the end of March. Doctors had drawn blood, a common practice in cases of unidentified fever. Pope Leo was concerned and despatched a chamberlain regularly to inquire as to Raphael's progress.

When he continued to grow weaker, Raphael summoned a notary to whom he dictated his will. Vasari affirmed that he sent his lover away with an allowance to live comfortably, and appointed the pope's notary, Baldassare da Pescia, as his executor. The unidentified lover may have been Margherita Luti, the daughter of a baker from Siena, now resident in Rome. She was sometimes refered to as La Fornarina (the daughter of a baker). In an aside, Vasari blamed Raphael's sudden illness on too much sexual intercourse. In Vasari's day, such a heroic libido would have been seen as an arsenal of virility and would have been greatly admired.

As he had no heir, Raphael divided his estate between his various collaborators, principally Giuliano Romano, Giovanni da Udine and Gianfrancesco Penni, and made a bequest to a cousin in Urbino who was a priest. In the middle of the night of 6 April, Good Friday, attended by his close friends, Raphael died. It was his thirty-seventh birthday.

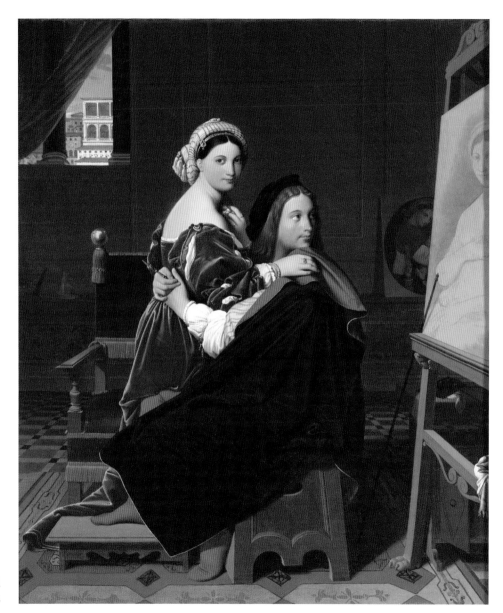

Raphael and
La Fornarina

Details from The Hall of Constantine

On the morning of Holy Saturday, the body of the painter was laid out in his home so that people could pay their respects. His painting, *The Transfiguration*, was placed beside his corpse. Raphael had died during the Sacred Triduum, which ended on Easter Sunday. There was little time to prepare for a funeral, for the next day was Easter Sunday, and during the following octave it would have been difficult to observe the obsequies. The cortège assembled on Saturday afternoon. Many members of the papal court attended, along with the pious confraternities who usually accompanied funeral processions. Fifty of Raphael's pupils carried torches, accompanied by a further fifty artists resident in Rome, making their way along the banks of the Tiber and crossing over into the heart of the old city. Thousands more gathered as the cortège arrived at the Pantheon, where Raphael had requested that he be buried. He had endowed an altar over which a marble statue of the Virgin Mary by his pupil, Lorenzo Lotti, was placed. Marcantonio Michiel noted in his diary that Pope Leo was distraught at the news of the painter's death.

On 12 April, Sebastiano di Piombo wrote to his collaborater, Michelangelo, informing him that 'Raphael of Urbino is dead'. He reported that Raphael's *garzoni*, far from mourning their master, were openly bragging that they intended finishing the Hall of Constantine in oils. Di Piombo asked Michelangelo to intervene on his behalf, as the *garzoni* were already on their way to Florence to ask the favour of Cardinal Giulio de' Medici, the ruler of the city and cousin of Pope Leo. Sebastiano believed that if Michelangelo could convince the cardinal, he might obtain the prize commission.

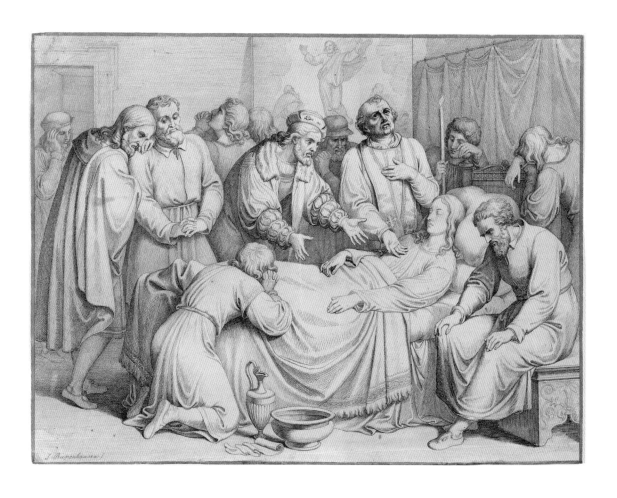

With the death of Raphael, one of the great artists suddenly vanished from the Roman scene. But there were others who gladly filled the vacuum. Michelangelo was to live for a further forty-four years, and succeeded Raphael as chief architect of St Peter's. He was also commissioned by Pope Clement VIII to paint the *Last Judgement* in the Sistine Chapel between 1536 and 1541, a quarter of a century after he had painted the ceilling. Between 1542 and 1549

The Death of Raphael

The Betrothal of Raphael and the Niece of Cardinal Bibbiena, *1813–14*

he painted the *Crucifixion of St Peter* and the *Beheading of St Paul* in the Pauline Chapel for Pope Paul III.

The Poor Clares of Monteluce showed extraordinary patience with Raphael, although they must have been frustrated and disappointed. Having first signed a contract for an altarpiece of the coronation of the Virgin in 1503, and having advanced thirty ducats, they renewed the contract in 1505 and again in 1516. While Raphael made preliminary sketches, he had never begun the work. In 1523 Giulio Romano and Gianfrancesco Penni drew up a new contract for the altarpiece, which they painted and delivered in two years. However, it was suspected that the two artists passed off on the innocent sisters an altarpiece that had been commissioned by Agostino Chigi for his family chapel in Santa Maria del Popolo.

Although his contemporaries refer to his graceful manner, physical attractiveness and popularity with women, there is no record of Raphael's marrying. The identity of the relative Cardinal Bibbiena intended Raphael to marry remains a mystery, although scholars speculate that it may have been the prelate's niece Maria, who predeceased Raphael and was buried near him in the Pantheon. In the late eighteenth century a letter was discovered which referred to a certain M. A. Margherita, the widowed daughter of Francesco Luti of Siena, who may have been his unidentified lover at the time of his death. The letter, dated 28 August 1520, the year of Raphael's death, stated that Margherita had entered a convent in Trastevere that day, presumably as a novice. There is no further trace of her and the records of the convent's residents have long since perished.

Cardinal Pietro Bembo, a close friend of Raphael who first

met the artist as a young man in Urbino, composed an epitaph in Latin which was carved on the sarcophagus.

*Ille hic est Raffael timuit quo sospite vinci
rerum magna parens et moriente mori.* *

**Here is Raffael, who, while he lived, Nature feared he might outdo, but in death, feared that she herself might die.*

The death of Raphael at the height of his powers and the summit of his success was both a tragedy and an incalculable loss. There were rumours that jealous husbands and envious artists might have poisoned him.

In Raphael's era many believed that destiny was dictated at birth, written in the stars and the alignment of the planets. Raphael lived in a predominantly Christian society which was often at war with itself. Born three decades after the invention of the moveable type printing press and a decade before the discovery of the New World, he enjoyed the support of many wealthy secular and religious patrons. While he had enormous success in his lifetime, giving rise to not a little envy, we are left wondering how much more he had to give to a world enchanted by his colours.

Raphael saw himself as a link in a chain of artists and architects. Styles developed and colours changed. The basilica on which Raphael worked as the second architect was not completed until almost a century after his death. Yet his legacy lives on, inspiring generations of artists and drawing millions to view his masterpieces in chapels and museums across the globe.

Tomb of Raphael

*And even as he embellished the world with his talents,
so, it may be believed,
does his soul adorn Heaven by its presence.*
Giorgio Vasari, *The Life of Raphael*

Epilogue

Four days after Raphael's death, the papal court was in mourning once more, this time for the death of the richest man in Rome, Agostino Chigi. Five thousand people gathered for his funeral, attended by eighty-six carriages, at the church of Santa Maria del Popolo. Along with works of art, lands, villas, palaces and castles, Chigi left 400,000 ducats. However, even his financial monopoly was coming to an end as the discovery of the Americas opened up new sources of riches.

The following year, on 1 December 1521, Pope Leo X died suddenly at the age of forty-six. The son of Lorenzo the Magnificent who had enjoyed unlimited wealth and feasted at sixty-five course dinners was gone. Leo had developed a fever and died so abruptly that Viaticum, the last anointing for a Catholic, could not be administered. His lavish spending on art in Rome, his political alliances to secure the Papal States and his efforts to promote his family had emptied the papal coffers. His sale of ecclesiastical benefices was not sufficient to support his extravagances and immersed the Holy See in debt.

There was no money in the treasury to pay for his funeral expenses, and half-burned candles, recently used at the funeral of a cardinal, were lit around the pope's catafalque. As the master of ceremonies, Paride de Grassi, vested the corpse, he noticed black mottled patches on the skin, similar to signs of arsenic poisoning that he had seen on cardinals' cadavers in the past.

On 17 December, the furnishings department at the Vatican, the 'floreria', sent seven tapestries to Johannes Belzer, a Roman pawnbroker. Leo's jewels were discreetly offered to family members at a discount. For all the ephemeral beauties of Leo's reign, the Church was irreparably damaged and schism had all but destroyed the Christian fabric of Europe.

Leo's successor, Adrian VI, condemned the corruption of the Roman Curia and initiated a short-lived reform which ended with his sudden death less than two years later in September 1523. Cardinal Giulio de' Medici, Raphael's patron and Pope Leo's cousin, succeeded him as Clement VII, reigning from 1523 until 1534.

Clement was immediately drawn into a conflict between Francis I of France and Charles V, the Holy Roman Emperor. Rome was sacked by Charles for four days from 6 to 10 May 1527, and the pope, who had taken refuge in Castel Sant'Angelo, was taken prisoner. He was liberated on the payment of a ransom.

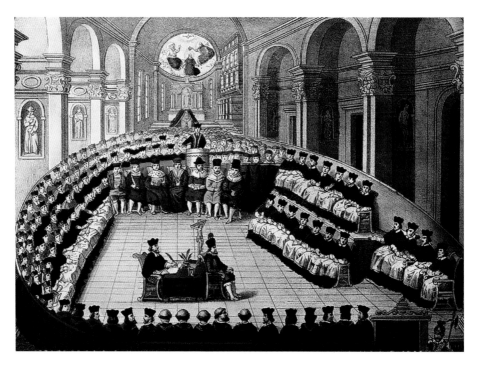

The Council of Trent

The Protestant Reformation, with Martin Luther as a seminal figure, continued apace as more reformers joined the movement, but Clement was ineffective in engaging with them to initiate essential reform in the Church. What was originally a protest at the corruption of the papacy ultimately led to the division of Europe along confessional lines.

In 1545, Pope Paul III finally gave in to pressure to convene an ecumenical council to address the reform of the Church. Held over three sessions, the Council of Trent ended in 1563 without reconciling the most vociferous reformers. The council fostered a dramatic explosion of devotional art, aimed at bolstering the faith of people whose belief had been profoundly challenged by the movement for reform.

List of Illustrations

Cover
Raffaello Sanzio, *Autoritratto* © Galleria delle Statue e delle Pitture degli Uffizi, Inv. 1890, n. 1706

Inside Cover
Detail from *The School of Athens*, Apostolic Palace © Serato / Shutterstock

Title Page
Raphael at the Age of 15 (engraving). Raphael (Raffaello Sanzio of Urbino) (1483–1520) (After) © Bridgeman Images

Preliminary Page 5
Map of Italy © Slava Gerj / Shutterstock

Preface
Bust of Raffaello Sanzio, known as Raphael. Background is a fresco painted by the artist. Chapel of San Severo, Perugia, Italy © Eavide Zanin / Shutterstock

Chapter 1
Pope Leo III crowning Charlemagne as emperor on Christmas Day 800 from *Chroniques de France ou de St Denis*, fourteenth century © Flickr Public
City of Urbino © Stefano Valeri / Shutterstock
Pope Eugenius IV. Wikimedia
City of Urbino © Giovanni Federzoni / Shutterstock
Pope Sixtus IV. Wikimedia
The Duke of Urbino, Federico da Montefeltro and son © Galleria Nazionale delle Marche, Urbino
A map of Rome engraved by Giacomo Lauro (1550–1605) in the sixteenth century © Alamy

Chapter 2
Roman Forum as seen from The Capitoline Hill © David Carillet / Shutterstock
Domus Aurea © Andrea Izzotti / Shutterstock
Melozzo da Forlì's fresco of Pope Sixtus IV with Platina. Wikimedia

Florence © Noppasin Wongchum / Shutterstock
Pope Martin V. Wikimedia
Donatello's Bronze David © Patrick A Rodgers, Flickr and Wikimedia
The Procession of the Magi by Gozzoli. Wikimedia

Chapter 3
Christopher Columbus © Everett Historical / Shutterstock
Portrait of Pope Alexander VI by Cristofano dell'Altissimo. Wikimedia
The Bull / *Inter Cetera*. Wikimedia

Chapter 4
The Artist's *Bottega*. Wikimedia
Raphael's self-portrait. Alamy.com
Raphael cartoon for *The School of Athens*. Wikimedia
Girolamo Savonarola Statue, Ferrara, Emilia-Romagna, Italy © Miti74 / Shutterstock

Chapter 5
Piccolomini Library in Tuscany © Botond Horvath / Shutterstock
The Golden Legend. Wikimedia
Michelangelo Buonarroti (1475–1564), master sculptor and painter of the High Renaissance. 1876 engraving by A Francois after a Michelangelo self portrait © Everett Historical / Shutterstock
Leonardo da Vinci (1452–1519), Italian Renaissance painter from Florence. Engraving by Cosomo Colombini (d. 1812) after a Leonardo self portrait. Ca. 1500 © Everett Historical / Shutterstock
The Baglioni Entombment Altarpiece, Galleria Borghese (permission pending)

Chapter 6
The Laocoon © DFLC Prints / Shutterstock
Donato Bramante's *Tempietto* © Classic Image / Alamy

List of Illustrations

Chapter 7

Bronze Pine Cone, Fontana della Pigna, at Courtyard of the Pigna of Vatican Museums, Vatican City © Pyty / Shutterstock

The Ceiling of the Stanza della Segnatura 1508 © Alamy

Two of Raphael's walls in the Stanza della Segnatura – *Siege of the citadel of Mirandola*, Claude Duchet (?–1585). Wikimedia

Sistine Chapel © R P Baiao / Shutterstock

Raphael. *Portrait of Pope Julius II*. 1511 © The National Gallery, London

Chapter 8

Pope Leo detail © Michael Collins (author's own)

Raffaello Sanzio, *Ritratto di Leone X con i cardinali Luigi de' Rossi e Giulio de' Medici*, Galleria delle Statue e delle Pitture degli Uffizi, Inv. Palatina n. 40 (Pope Leo and two cardinals) © Uffizi Gallery

Drawing of Annone/Hanno the elephant © Kupferstichkainett, Staatliche Museen zu Berlin. Photograph: Dietmar Katz

Plans for St Peter's. Wikimedia

Johannes Gutenberg, Inventor of the Printing Press © Glasshouse Images / Alamy. Photographer: J T Vintage

All tapestry photographs © Michael Collins (author's own)

The Printing Press: Opera Nuova Giovanni Antonio, Giovanni Antonio Tagliente (Italian, Venice ca. 1465–1528 Venice). Harris Brisbane Dick Fund, 1935. The Met.

Belvedere Courtyard © Volodymyr Nik / Shutterstock

Chapter 9

Friar Johann Tetzel Selling Indulgences by Franz Wagner. Wikimedia

Martin Luther in his Study. Provenance not found

Raphael Loggia, Gaspard Miltiade. Wikimedia

Disputation of the Holy Sacraments © The Picture Art Collection / Alamy

Villa Farnesina © Sergey-73 / Shutterstock

All tapestry photographs © Michael Collins (author's own)

Chapter 10

Raphael and La Fornarina by Ingres, Jean-Auguste-Dominique. Kind permission Harvard Art Museums/Fogg Museum, Bequest of Grenville L Winthrop. Photo ©President and Fellows of Harvard College

Details from The Hall of Constantine © Michael Collins (author's own)

Death of Raphael. Colletion of Mr and Mrs Francis D Logan and Van Day Truex Funds; 2012; Artist: Johannes Riepenhausen (German; Goettingen 1788–1860 Venice); Subject: Raphael (Raffaello Sanzio or Santi)

The Betrothal of Raphael and the Niece of Cardinal Bibbiena,1813–1814, Jean-Auguste-Dominique Ingres (French, 1780–1867), oil on paper mounted on canvas. Walters Art Museum (37.13): Acquired by Henry Walters, 1903.

Tomb of Raphael © Prisma Archivo / Alamy

Epilogue

Council of Trent. Provenance not found